Roger Fenton

OF CRIMBLE HALL

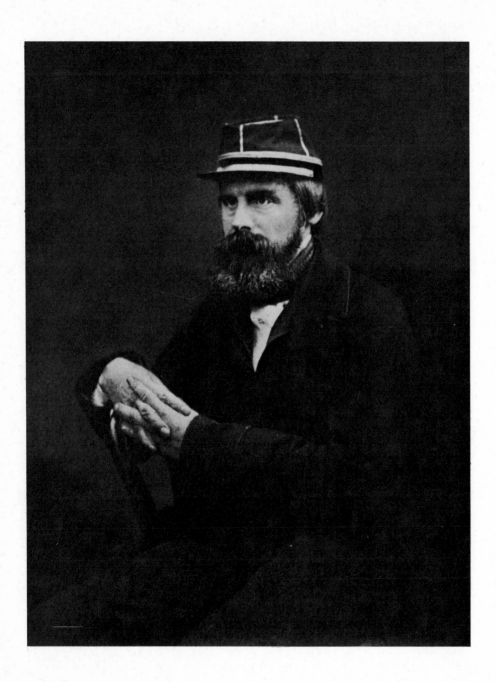

Roger Fenton in a borrowed Kepi,
photographed by Doctor Diamond.

John Hannavy

Roger Fenton

OF CRIMBLE HALL

DAVID R. GODINE · BOSTON

First published 1976 by
David R. Godine Publisher
Boston, Massachusetts

LCC 74-24786
ISBN 0-87923-127-0

Text set in Monophoto Ehrhardt by London Filmsetters Limited
Printed in Great Britain by
the Westerham Press, Westerham, Kent
Designed by Peter Guy

Contents

List of Illustrations in the Text

Acknowledgements

The author is indebted to many people and institutions for their help in the compilation of this biography. In particular, thanks are due to The Guildhall Library, London; The Kodak Museum; The National Trust; The Louis Rothmans Collection of Victorian Photographs by Francis Frith; The British Museum; Bodleian Library, Oxford; Manchester Public Libraries; Patents Office; Rev. John Wall; Arthur T. Gill; Southeby's Belgravia; Christies; Radio Times Hulton Picture Library; Hull University Library; Scottish United Services Museum, Edinburgh Castle; A. E. Haswell Miller, MC., MA., RSW; Peter le Neve Foster; The Dela Rue Company; Cotswold Collotype Company; Rochdale Public Libraries; National Library of Wales; National Army Museum; Ilford Limited; The Victoria and Albert Museum; Granada Television Ltd; Illustrated London News; Photomatic Limited; Stonyhurst College; Edinburgh Public Libraries; Cambridge University Library; UMIST Technology Library, Manchester; Wigan Public Libraries; College Library Service, Wigan & District Mining & Technical College; Liverpool Public Libraries; Royal Library, Windsor Castle; The Royal Archives, Windsor Castle; The Earl of Harewood; The Science Museum; Black Watch Museum, Perth; Scottish Arts Council; The Mansell Collection; Times Newspapers Limited; Greater London Council.

Particular thanks are due to the Royal Photographic Society and its staff without whose efforts this book just would not have been possible, and to my wife, Eileen, for her help in correcting the typescript.

Thanks also to the many individuals who have each added some small piece to help complete the jigsaw.

Chronology

1819 Roger Fenton born at Crimble Hall in Heywood,
 near Rochdale, Lancashire.
1838 Began studies at University College, London.
1841 Studied art in Paris.
1844 Returned to London.
1847 Qualified as a solicitor;
 married Grace Maynard;
 Photographic Club (Calotype Club) founded.
1851 Called to the Bar; took up photography;
 Great Exhibition held
 (the first exhibition to include photography).
1852 Society of Art's Photographic Exhibition
 (the world's first photographic exhibition).
1853 The Photographic Society founded.
1854 Fenton photographed the Royal Family;
 started work for the British Museum.
1855 The Crimean expedition.
1856 Appointed chief photographer to
 the Photogalvanographic Company.
1859 First publication of the *Stereoscopic Magazine*.
1862 Fenton abandoned photography.
1869 Fenton died at 2 Albert Terrace, Regents Park, London.

Foreword

THIS BIOGRAPHY of one of the most important figures in the history of photography is concerned with establishing Roger Fenton's major contribution to that history and with placing this in its proper perspective. That he photographed the Crimean War is perhaps the only well known fact about him. His Crimean pictures now grace every book on the history of photography and a number of history books on the progress of the war, but little attention has been paid in the past to the major proportion of his output which is far removed from war reportage. As will be revealed in these pages, Roger Fenton was not a photographer whose work could be classified or slotted into neat groups. Although he is known today as a war photographer, this branch of his art accounted for only 360 pictures out of the many thousands he produced. If he is to be classified according to the subjects to which he devoted most time, then Roger Fenton was a museum photographer, or an architectural photographer: he produced many more photographs in these spheres than he did in the Crimea.

Fenton would not have liked to be classified as a particular type of photographer—except perhaps as a *professional*. He turned his attention to every subject which interested him from the photography of statues in the British Museum to those cluttered still-lifes which were so much a part of the Victorian photographic scene. His work included beautiful landscapes and superb architectural work—with just a sprinkling of those emotional 'tableaux' which were fashionable in the 1850s.

Roger Fenton's name is associated with almost every important step in the development of photography in the short period of time in which he was working. This book sets out to chronicle his life and his work, with the help of photographs, letters and notes drawn from the major collections in this country as well as small items of information or photographica which have generously been provided by the many hundreds of people who have answered my pleas for help in the course of the last two years.

John Hannavy
WIGAN, 1974

Chapter 1
The Fenton Family

'In a "List of Lancashire Worthies" at page 800 of the fourth volume of Mr Baine's "History of the County Palatine and Duchy of Lancaster" occurs the name of "Roger Fenton, divine, author of a treaty against usury dated 1615". His living descendant Roger Fenton MA, the well-known photographer, attracted during the summer of last year[1858] to his patrimonial estate, the residence of his father John Fenton, was tempted to take some photographs of the large size of places of interest in the neighbourhood, together with a series of stereographs, of which this and the preceding are a portion'.

THUS STARTS the descriptive text accompanying a plate entitled *New Bridge on the Hodder, Lancashire* in the third volume of Lovell Reeve's *Stereoscopic Magazine* published in 1859. In fact, that mention of the Reverend Doctor Fenton (1565–1616) is the first known mention of the family. Dr Fenton was an eminent theologian of his day and responsible, in part, for the translations of several passages in the James 1 edition of the bible. Like his namesake three centuries later, he lived in London despite his Lancashire connections and, also like his namesake and descendant, he died in his fiftieth year. He had, at the time of his death, the title deeds of lands at Crimble in Lancashire which apart from a short period during his son's life, remained in the family until Roger Fenton MA left his home to live in London. (Just how these lands passed out of the family will be seen in the following narrative.)

Roger Fenton's great grandfather, James Fenton, who died in 1819, left a small sum of money and the family estates to Joseph, his son, who soon added Bamford Hall to the family fortunes. Bamford was bought from Robert Hesketh Bamford (an assumed surname to please his wife's family).

At this time the family appears to have derived its income from a business entitled 'J & J Fenton and Son', Flannel Manufacturers of Cheetham Street in Rochdale and of Crimble; but in the same year as his father's death Joseph founded the banking house of Fenton, Roby and Cunliffe. After a few years his sons appear as partners with the mention of James and John Fenton, Bankers of Crimble and Joseph Fenton, Banker of Bamford House. It appears that while father lived at Bamford, the two sons, both married by this time, shared Crimble Hall.

1819 was the year in which the fourth of John Fenton's children, Roger Fenton, the subject of this book, was born. John had married Elizabeth Apedaile, daughter of William Apedaile of Newcastle-upon-Tyne, in 1814 and their first child, John junior, was born in 1815. He was followed shortly by Elizabeth (Betsy) and then Joseph. Roger was followed by Sarah, William and Ann. John junior died in 1828 at the age of thirteen and Ann died in 1843 at the age of nineteen. When Roger was ten years old, his mother died at the early age of thirty-seven and in the following year John Fenton married again–this time his bride was the twenty-seven year old Hannah Owston of Brigg in Lincolnshire who bore him a further ten children–Maria, another John, another Ann, James, Arthur, Robert, Jane, Albert, Emily and Ellen. Of these seventeen children, fifteen outlived their father. John's brother James, on the other hand, produced a modest two

children by his wife Sara.

By 1820, Joseph senior had added further lands to the Crimble estates and bought a further few acres to extend the lands around Bamford Hall, but the major step forward in the family prospects came in 1826 with the building of extensive cotton mills on the banks of the Roch River at Hooley Bridge, Heap, near Heywood. This must have been one of the most important development projects Rochdale had ever seen. The mill is reputed to have cost about £100,000 and was designed to be fireproof. Its vast area, enclosed by five storey-high walls, covered almost 60,000 square feet and was lit by gas – a novel form of lighting for such early days. The factory had its own gas-manufacturing plant and it was this innovation and the need for fireproofing which led to the enormously high building cost. Fenton and Schofield, as the new enterprise was known, manu-factured cotton – both the spinning and the weaving being done in the large mill. The company was very conscious of its responsibilities to its workers and the records show that the staff of Hooley Bridge Mills, who lived in a specially built village of tied cottages, were amongst the 'best clothed, fed and educated of any village in Lancashire'.

The family fortunes seem to have taken a definite turn for the better as a result of this vast investment and, by 1829, Joseph was wealthy enough to add the Lancashire manors of Ribchester, Dutton and Bayley to the growing estates. The banks prospered too and by the early 1830s the title had been changed to 'Fenton and Roby' and the company had large offices in Old Market Street in Rochdale.

At the age of forty-one, John Fenton, Roger's father, decided to enter politics and, in 1832, became the first Member of Parliament for the newly formed Rochdale Constituency. This was the First Reformed Parliament and John Fenton, a Liberal, won the seat from the Conservative John Entwistle by thirty-one votes. This may not seem many but there were only 687 registered electors in the constituency and their votes were shared amongst three candidates. Two years later he had to stand for re-election after the demise of the short-lived government but won by a narrower margin than before. At a third general election in as many years he lost his seat to Entwistle by forty-three votes but was re-elected in 1837 after a by-election caused by Entwistle's death. This time his majority was a mere twenty-five. That election guaranteed his seat at Westminster until he retired from politics before the 1841 general election, when his seat was taken by his Liberal successor William Sharman-Crawford. (Crawford contested the election against the conservative candidate, James Fenton, John's brother!).

It is an interesting aside at this point to note that the MP for Chippen-ham in Wiltshire, also a Whig, was William Henry Fox Talbot, the inventor of the calotype process which was to be Roger Fenton's intro-duction to photography in 1851. Talbot also lost his seat in 1835 and returned to his photographic researches. By the end of that first year out of Parliament, Talbot had produced an image by the 'invention for photogenic drawings'. He continued with his researches and within a short space of time was producing quite recognisable images.

Joseph Fenton died in the summer of 1840 after an industrious and financially successful life. He left well in excess of half a million pounds to his two sons, to be shared equally between them. So, James and John now each owned half their father's share in the mill, half of the banking interests and about a quarter of a million pounds in property and investments. To John went Crimble Hall and the estates of Lower Crimble and Crimble itself. To James went Dutton and Bayley and Clegg Hall together with the house and lands at Bamford. Ribchester probably went to John Fenton. There were, in addition, lands at Wild House, Butterworth and the estates of Birchinley Manor. In terms of commercial interests, there were the Heywood mills, the banks, the bobbin mills at Hurst Green near Blackburn (about which we will discover much in the course of this account) and several other smaller concerns.

For some reason, neither John nor James could involve themselves in the businesses and John's share soon passed to Joseph Fenton, Roger's elder brother. His uncle James's share passed to another Joseph Fenton, James's son. The bank was disposed of separately, being shared between Roger's younger brother William and the same cousin Joseph. His other cousin, James, took over the management of the Dutton, Bayley and Clegg estates and all were supposed to be wealthy enough to have no worries for the rest of their lives.

About this time, rate books for various Lancashire villages show further proof of the family's extensive holdings–the little village of Hurst Green seems to have been at least partially owned by the family. In addition to the already mentioned bobbin mill (which was at this time managed by a carpenter by the name of Chippendale) and a number of cottages, James and John, and later their heirs also owned the inn just outside the village which had been christened The Fenton Arms. (It is still standing and thriving today under the name of The Punch Bowl).

At twenty-eight years of age, and with every prospect of becoming a successful lawyer, Roger married Grace Maynard in 1847. By her he would have three daughters, Eva, Rose and Ann. At this point in a biography of any important figure, it would seem apt to give a brief insight into the subject's private life but, with Fenton, this is quite impossible. He was a very public 'public figure' and, as if to compensate for his extrovert public image, he shrouded his private life in a cloak of secrecy. Little is known of 'Fenton the man' except his address–2 Albert Terrace in Primrose Hill near Regents Park, but an idea of his family life can be gleaned from his letters home from the Crimea.

In the Crimea where any minute might be one's last, one would expect Fenton's letters to his wife to be filled with private thoughts and thus revealing to us now, but this is not the case. Not for Roger Fenton the luxury of sentimental letters home to his family. What he did write were historical commentaries on the war to his publisher or to his wife with the request to each that they pass the correspondence on to the other. The letters had to be kept, too, for he was certain of their future importance as historical documents. Perhaps there were other letters which we know nothing about–although that is unlikely as there are references to his health

and welfare in the letters which have survived. It is the opinion of this writer that Roger Fenton's family were of secondary importance to his photographic work. There are no pictures of his wife and children – unless that is his wife with Eva and Rose in *Hush Lightly Tread*, produced in 1856. The only other 'family' picture is that of *Grandfather Maynard on Horseback* reputed to have been taken at Harewood in 1859.

Chapter 2
The Beginnings of Organized Photography

ROGER AND HIS BROTHER William began their studies at University College London in 1838. After completing a Master of Arts course, Roger spent three years under the influence of the painter Charles Lucy and then travelled to Paris to continue studying art. His teacher in Paris was Paul Delaroche to whom is attributed the famous comment 'from today painting is dead'. Delaroche is presumed to have made this exclamation upon seeing his first photograph, a daguerreotype, but later modified his prophecy once he realised that photography could be a useful tool to the painter.

Fenton had arrived in Paris in 1841 and, three years later, after minor success as a painter, but with an awareness that he would never earn a living in that way, he returned to London and began a course of study which led to him qualifying as a solicitor in 1847. He was called to the Bar in 1851 but, instead of practising as a barrister, he joined a firm of solicitors with offices at 50 King William Street in London.

In the three-year period between his return to England in 1844 and his subsequent qualification as a solicitor in 1847, he dabbled with the calotype process. His interest in photography had been aroused while in Paris where he had come into contact with a number of eminent daguerreotypists in Delaroche's studio. The daguerreotype seemed rather limiting, however, with its uniqueness of image. The facility of multiple printing offered by the calotype together with the pleasing soft colour of the prints obtained seemed to give this process far more potential and Roger Fenton started taking photographs.* It is probable that he had experimented with Daguerre's process in Paris but there are no existing examples of that work.

With the introduction of this simpler process, a number of interested amateurs started to work in photography and it was, therefore, only a matter of time before they teamed up in some sort of association. That inevitable step forward came in 1847 with the coming together of twelve interested calotypists to form the Photographic Club, more usually referred to today as the Calotype Club. The original members of this august body were all eminent people in their fields. The initial move towards the club's formation came from Peter W. Fry and he brought together Peter le Neve Foster (barrister), Frederick Scott Archer (artist, sculptor and later inventor of the wet-plate process), Roger Fenton, Robert Hunt, Joseph Cundall (photographer and publisher) Charles Vignoles (civil engineer), F. W. Berger, Hugh Owen, Edward Kater, Sir William Newton and Dr Hugh Diamond. Foster was the secretary of the Society of Arts—a fact which went a long way towards ensuring the success of the club's ventures. With his influence and position he formed the bridge between the embryonic Photographic Club and the established Society of Arts, thereby gaining recognition for photography in its infancy.

The membership of the club was small and remained so for some years. The major restriction placed upon the growth of photography in England was the fact that both the daguerreotype and the calotype were covered by jealously guarded patents, and all those who practised in either process had to be licensed by the patent-holders. In the case of the Calotype Club, each member was licensed by Fox Talbot.† This position remained long after Scott Archer had offered his collodion process to anyone who wished to

*The Daguerreotype process had been introduced in 1839 in France by its inventor, Louis Jacques Mande Daguerre. His process was ingenious but limited in its application and is nowadays often referred to as the 'false start' of photography. The process used a silver copper plate, polished and coated with a light sensitive emulsion. After exposure the plate was developed over mercury, using the vapours as the developing agent. The image the plate yielded was a unique positive image. Further copies could only be made by photographing the processed Daguerreotype plate. The Calotype process, introduced by Fox Talbot in England at about the same time produced a paper negative which could be greased and used as a transparent negative from which prints could be made. It was with the introduction of Talbot's process that the words 'negative' and 'positive' were used for the first time in photography. Talbot's process, although producing a much coarser image than the Daguerreotype really set the pattern for the modern photographic process.

†In Scotland Talbot's patents had no jurisdiction and there was complete freedom to practise photography. In spite of this freedom, the new art did not achieve vast popularity, and, amongst those few who did work seriously, only two or three achieved any great degree of success or recognition. Most important of these, of course were David Octavius Hill and Robert Adamson, and, to a lesser extent, Robert's father, Dr John Adamson, who had initially taught his son the calotype process.

To Mr. N. HENNEMAN,

Sun Picture Rooms,

122, Regent Street, London.

Sir,

 Understanding that the Patentee of the Photographic process, known as the Talbotype or Calotype, has no objection to that process being used by Amateurs, who pledge themselves to use it BONA FIDE, FOR THE PURPOSE OF AMUSEMENT ONLY; *(and that they will purchase from your Establishment the Iodised Paper belonging to the said Patent Invention, which they may require) and also that they will not make any such use of the Art as to interfere injuriously with your Establishment, but will immediately discontinue any such use of it, on your requesting them to do so. Now, I being desirous of practising the aforesaid Patent Invention as an Amateur only, and without any view to profit, either directly or indirectly, am willing to give you the pledge and assurance above mentioned.*

Witness my hand, at *this* *day of* *in the year* 184

Witness to Signature

Form to be signed before taking up calotype photography. All calotypists had to be licensed by Talbot or one of his agents.

use it, without any patent restrictions.

By about 1851 the strange situation had arisen whereby photographers found themselves still requiring licenses from Talbot for using the calotype invented by Talbot, the waxed paper process invented by Gustave le Gray and the albumen process invented by Niépce St Victor. Talbot claimed that his patents covered the process detailed in his specifications and every other process which produced a photographic image, however achieved. When Scott Archer announced his wet-plate process photographers everywhere felt that at last their long awaited freedom was imminent. They were, however, sadly mistaken!

In the meantime, in addition to his legal practise and his associations with the club, Fenton had still found time to pursue his first love, painting, and had had three paintings in as many years accepted and exhibited at the Royal Academy. The style in which he painted was very definitely a product of the atmosphere of Victorian England and, in any other context, would not have been taken seriously. With titles like *The letter to Mamma: what shall we write?* in his paintings, and *Hush, Lightly Tread, Still Tranquilly she sleeps* in his photography, it becomes evident that in the few moments when there were no commercial pressures upon him, Fenton revelled in recording the incidental in a 'tableau vivant' manner. These 'tableaux' were often the subjects of a long series of photographs.

1851, however, was destined to be a great year for British photography. The Great Exhibition took place in that year and amongst the many exhibits which drew visitors from all over the world was the first recorded major exhibition of photography, in which the work of leading photographers both in Europe and the United States was put on show. Although this was merely a section for photography within a larger exhibition, it was

proof of the fact that exhibitions of photography were viable and highly appreciated propositions. The members of the Calotype Club, led by Joseph Cundall, now actively pursued the idea of arranging their own exhibition. Fenton, however, was not present at these early discussions, as he had left for France where he intended to study the organisation of the Societé Heliographique, the world's first photographic society which had been formed earlier in 1851.

He returned to London and contributed the following paper, dated March 1852, to the magazine *The Chemist*. It is transcribed here in full as it is perhaps one of the most important documents in the history of the organisation of photography.*

PROPOSAL FOR THE FORMATION OF
A PHOTOGRAPHICAL SOCIETY

It affords us much pleasure to be enabled to inform our readers that active measures are now being taken for the formation of a Society, the object of which is, the advancement of the beautiful art of photography. The want of such a Society has long been experienced, and we feel assured that all interested in the art, whether professionally or as amateurs, will hail with delight its formation and hasten to avail themselves of its advantages. The number of photographists in this country is very great, and the Society will no doubt muster a long list of members as soon as it is fully formed, and certainly it will be joined by all of any note, or who, if not publicly known, are at least desirous of advancing photography and of perfecting themselves in the knowledge and practice of it.

The following circular is being sent to all photographists whose addresses are known to the projectors of the Society. We insert it for the benefit of those readers of this journal who have not received it, earnestly calling upon them to render all the assistance in their power to advance the accomplishment of an object which must confer so much benefit on the photographic art.

During the few days which will elapse between the writing of this notice and its reaching the hands of our readers, some further progress will be made. The fullest information may be obtained by application to the Editors of THE CHEMIST, 23 Paternoster Row, London; or to R. Fenton Esq 2 Albert Terrace, Regents Park or at 50 King William Street, City.

The science of photography, gradually progressing for several years, seems to have advanced at a more rapid pace during and since the Exhibition of 1851. Its lovers and students in all parts of Europe were brought into more immediate and frequent communication.

Ideas of theory and methods of practice were interchanged; the pleasure and instruction were mutual. In order that this temporary, may become the normal, condition of the art and of its professors, it is proposed to unite in a common society with a fixed place of meeting and a regular official organisation, all those gentlemen whose taste has led them to the cultivation of this branch of natural science.

*There is another document under the same title of which this writer has a copy, and this second document is of much greater length. The authorship of the second paper is uncertain, and, although the language used in it is of a style very similar to that used by Fenton, the handwriting is dissimilar. Certain eminent writers attribute it to Claudet. The first is dated March 1852.

As the object proposed is not only to form a pleasant and convenient photographic club, but a society that shall be as advantageous for the art as is the Geographical Society to the advancement of knowledge in its department, it follows necessarily that it shall include amongst its members men of all ranks of life; that while men of eminence, from their fortune, social position, or scientific reputation, will be welcomed, no photographer of respectability in his particular sphere of life will be rejected.

The society then, will consist of those eminent in the study of natural philosophy, of opticians, chemists, artists, and practical photographers, professional and amateur. It will admit town and country members.

It is proposed that the society should have appropriate premises, fitted up with laboratory, glass operating room, and salon in which to hold its meetings. That such meetings should be periodically held, for the purpose of hearing written or verbal communications on the subject of photography, receiving and verifying claims as to priority of invention, and for the exhibition and comparison of pictures produced by different applications of photographic principles, making known improvements in the construction of cameras and lenses, and, in fine, promoting by emulation and comparison, the progress of the art.

That the proceedings of the society shall be published regularly in some acknowledged organ, which shall be sent to all subscribing members.

That a library of works bearing upon the history, or tending to the elucidation of the principles of the science be formed upon the premises, and at the expense of the society; to be used by the members subject to such rules as may hereafter be agreed upon.

That the society should publish an annual album, of which each member should receive a copy who had contributed a good negative photograph to its formation, other members having to pay.

Before any progress can be made in the organisation of such a society as the foregoing, it is necessary first to ascertain the amount of support which it would be likely to obtain. – If those gentlemen, therefore, who feel inclined to become members of such a society, will send their names and addresses to R. Fenton Esq, 2 Albert Terrace, Regents Park, or at 50 King William Street, City, together with any suggestion which may occur to them individually, on the perusal of this outline of a plan, arrangements will be made, as soon as a sufficient number of persons have sent in their names, to hold a meeting in some central situation, to which they will be invited, to discuss the matter and to elect a committee for the organisation of a society.

After the society has once been organised, persons who may in future wish to become members will have to be proposed and seconded, a majority of votes deciding their election.

An entrance fee of £2.2s is proposed, and a yearly subscription of £1.1s.

There is no doubt that this document was produced as a result of very careful consideration of the role any successful society would need to play

in the country. Roger Fenton's plans for the organisation of the venture were far-sighted and comprehensive. (What a superb record of Victorian photography these projected annual albums would have made for those of us trying to piece the story together today.)

Although that paper appeared in March 1852 it was not until January of the following year that the first meeting of the Society was held. On 20 January at 4 pm, in the Great Room of the Society of Arts, the Photographic Society was born, with Sir Charles Eastlake as Chairman and Fenton as Honorary Secretary. The chair had originally been offered to Fox Talbot but he turned it down.

In the intervening period between the advertisement and the meeting, the provisional committee which had been formed had not been idle. The committee presented its report to the inaugural meeting and it was read by Fenton. In it he describes much of the hard work that had been necessary to take the idea of a society and mould it into reality.

The want of a centre of union is not now felt for the first time among photographers. Attempts were made at an early period in the history of the art to establish some kind of cooperation among those who were devoting their attention to this study. At that time, however, the number of persons so engaged was so limited, that no organisation of an extensive character was possible. A club, however, was formed [the so-called Calotype Club], and meetings were periodically held at the houses of members of it, and it is beyond a doubt that the progress of the art was thereby much advanced, and many of the difficulties which we should otherwise have now to encounter were cleared out of the way. Some of the gentlemen forming part of that club have rendered the most effective assistance in the construction of what we may now call a permanent Photographic Society. In the winter of 1851–52, it appeared as if the time were come for more vigorous exertions. The impulse given by the Great Exhibition had so increased the number of photographers, and the art itself had, by the competition and comparison which that exhibition induced, been so improved, that it was evident it was about to enter a new phase of its history. The formation of a Society in Paris, showing the views of our neighbours as to the necessity of methodical co-operation, was an additional confirmation of the opinions as to the necessity of an English Photographic Society. With these views a committee was formed, and met for the first time at the office of the *Art Journal*. At the very threshold of their undertaking they were met by a difficulty arising from the existence of a patent taken out by Mr Talbot, the inventor of the art. To do away with this difficulty, a meeting was arranged between Mr Talbot and the committee, and the subject was thoroughly discussed, with an earnest desire on the part of the committee and the patentee to arrive at a satisfactory arrangement. Unfortunately, an independent Society was found incompatible with the existence of the patent and the committee was therefore adjourned *sine die*. In the course of the proceedings however, there was shown so strong a feeling in the public mind as to the desirableness of a society, and the

number of persons willing to join was so considerable, that the committee foresaw that their present failure could only be of a temporary kind. It was now obvious that at this time the existence of the patent was the great obstacle, not only to the formation of the society, but to the improvement of the art itself. Few were willing to expend much time and labour on the art, upon the study of which they were told they had no right to enter without permission. As it was known that Mr Talbot's object in taking out a patent had been principally to establish definitively his claim to the invention, it was resolved to represent all these circumstances to him. Sir C. Eastlake and Lord Rosse, as the official representatives of art and science in this country, kindly undertook to be the exponents of the general feeling; and on the receipt of a letter from them, Mr Talbot abandoned the patent so far as was possible consistently with existing engagements. No difficulty now remained, and accordingly at the commencement of the present season, the committee was called together again, and a society constituted, which we are now met formally to inaugurate.

Although Fenton wrapped it up nicely, it was not as simple as it sounded. Getting Talbot to release the patent restriction was a long and arduous task – and he only agreed ultimately if he could retain control over all professional uses of his process. Photographers engaged in professional portraiture still required to be licensed by Talbot.

The original Calotype Club members were, indeed, central to the development of the Society and seven of them, including Fenton, Dr Diamond and Peter Fry, were elected to serve on the Society's first Council. However, during the months leading up to the inaugural meeting, they had certainly not devoted their entire time towards that end. While Fenton had been in France studying the Paris Society, Cundall and others, as a result of the Great Exhibition, had decided to organise a photographic exhibition themselves. This time, however, the exhibition would be devoted entirely to photography, and, as such, would be the first such undertaking in the world.

The exhibition opened at the Society of Arts on 22 December 1852 and, after returning from a business trip to Russia, Roger Fenton read an address at the opening soirée. He exhibited thirty-nine photographs, most of which, sadly, no longer survive. One of these was his only recorded photograph of Crimble Hall, his birthplace in Lancashire.

The evening's proceedings were recorded in the pages of the *Illustrated London News* on New Year's Day 1853 and the report was not altogether complimentary:

The works of Mr Fenton, Sir William Newton, Mr Shaw, Mr Goodeve, Mr Archer, Mr Horne and Dr Diamond are, with several others respectively, examples of much interest. Many among them are pictures of exceeding beauty, and curiously suggestive; but many would not have passed beyond the portfolio of the artist, since the subjects have been badly chosen and the results obtained are very unsatisfactory. Mr Fenton, on the occasion of the opening of the exhibition, read a paper

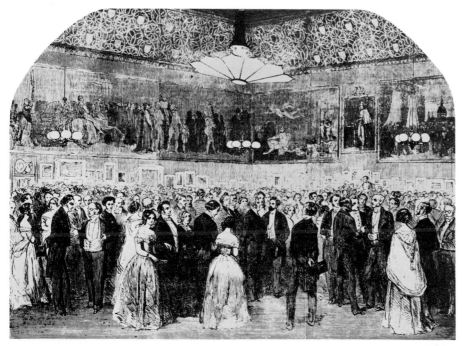

Soiree of Photographers in the Great Room of the Society of Arts. This engraving appeared in the *Illustrated London News* alongside a report of the opening of the exhibition, the first of its kind in the world, which had opened its doors on 22 December 1852. The *Illustrated London News* promised its readers that it would frequently report the progress of the art of photography, a promise which it certainly lived up to although many of the reports were very critical of the work exhibited.

on the 'Present Position and future Prospects of the Art of Photography' in which he sketched briefly the present state of our knowledge, and judiciously pointed out the most important points for research. 'Though the excellence of the specimens now exhibited' says Mr Fenton, 'might allow photographers the indulgence of self-complacency, still everybody feels that, as an art, it is yet in its infancy, and that the uses to which it may be applied will yet be multiplied tenfold'.

The *Illustrated London News* had shown an interest in photography from the beginning but had never shown itself to be so blinded by the new art form that it would accept less than perfection – even from a science in its infancy. In October 1852 it had announced the publication by Dogue of the first part of *The Photographic Album* with a sharp criticism of Fenton and his technique. After an initial two or three paragraphs regretting Fox Talbot's restrictive approach to potential users of the calotype and waxed paper processes, the article went on to say:

> The four calotypes now published have been executed by Mr Roger Fenton and they certainly mark the commencement of a new era in photography. The views are such that an artist would have selected, and they form indeed, studies from which an artist might, with advantage, copy. Beautiful, however, as these calotypes are, they are far from perfect, and as we deem it important that we should at once direct attention to their defects, and thus lead, as we hope, to the desired improvements, we venture, in the best spirit of criticism, a few remarks. The author of these pictures has adopted, probably, the best form of manipulation, and he has certainly produced photographs which few can rival. But Mr Fenton and all other photographers have yet much to learn before they can produce pictures which shall be reflexes of nature

in the beautiful gradations of light and shadow. If we take up either of the four photographs in this album, we cannot but observe that the high lights and the shadows are more decidedly contrasted than in nature, and want the harmonious blending of the middle tones, which are the great charm of the picture. In the 'Village Stocks', the five posts; in the 'Old Well Walk', the front of the mansion; and in 'Tewkesbury Abbey', the windows of what we understand to be a conservatory are offensively white, in contrast with the trees, which are in deep indistinct shadow. The details of the 'Old Barn' itself are beautiful, but the rick of corn and trees on the left of the picture are in unnatural gloom.

To overcome these defects it is important to attend most strictly to a few physical facts:

1. Reflected radiation from differently-coloured surfaces are not equally *chemically active*, under any circumstances of illumination.

2. The energy of chemical action is not directly proportional to the amount of illumination, as measured by the eye.

3. The disagreement of the illuminating and chemical radiation, being different for different chemical combinations, their exact relations for each particular sensitive surface should be ascertained.

Now, as the surface of the white posts in the first named photograph, when strongly lighted by the sunshine, radiated at least seven-eighths more chemical rays than did the dark brown stems of the trees which were in shadow, a better picture of these would be produced in one minute than there would be of the trees in eight; and as the effect before us was produced by an equal exposure of the calotype paper to every part, the trees are indistinct, and the posts lines of intense white light. The same result is unpleasantly evident in the strong contrasts between the white spots, which we believe to be daisies, and the greensward, in 'Tewkesbury Abbey'.

The most effective general mode of obviating these defects will be to work under a clear sky, when the sun is shining; but when it is illuminating the sombre parts of the picture, leaving all such as are light in colour under the influence of diffused light only.

The best results will be obtained by operating with a lens reduced to the smallest possible size; thus avoiding all extraneous light, and with a paper sufficiently sensitive to be acted on by the weakest radiations. When the sun is shining on a building, we see, howsoever deep the shadows may be, the detail of all the parts in shadow; but in copying such a building, under such circumstances, we get a very disproportionate effect. In diffused daylight, although a longer time would be required to obtain a good result, the result, when obtained, would be far more harmonious and pleasing.

As no letter-press description accompanies these photographs, we may possibly aid many of our readers by explaining the process by which they have been obtained. Mr Fenton has been celebrated for the success with which he has followed the process of M. Gustave le Gray upon waxed paper; and we presume, therefore, these pictures have been thus executed. Attention to the following directions will enable any one to

produce good pictures.

Paper selected of good quality is placed upon a hot plate and thoroughly impregnated with white wax, all the superfluous wax being removed by means of blotting paper. Some rice paper is prepared by infusing 250 grammes of rice in three litres of distilled water, until the glutinous portion, and that only, of the rice is dissolved. In this is to be dissolved, of

Sugar of Milk	40 grammes
Iodide of Potassium	15 grammes
Cyanide of Potassium	80 centigrammes
Fluoride of Potassium	50 centigrammes

Into this, when filtered, the waxed papers are placed, one by one, and allowed to soak for half an hour or an hour; they are then removed and carefully dried.

These sheets are rendered sensitive when required by the following:

Distilled water	150 grammes
Nitrate of Silver	10 grammes
Acetic acid	12 grammes

In this solution the papers are immersed for a short time, care being taken to remove all air bubbles from the surface of the waxed paper. These papers, being carefully dried in the dark, may be kept for a day or two for use.

After exposure in the camera obscura for the required time, which can only be discovered by experience, but which varies from 1 minute to 30 minutes, with the character of the light and the object, the image is developed by placing the picture in a bath of:

Distilled water	1 litre
Gallic Acid	4 grammes

After being fully developed, the photograph is fixed by soaking for some time in:

Filtered water	800 grammes
Hyposulphite of Soda	100 grammes.

Then, being well washed and dried, it forms a well-defined *negative* picture, from which any number of *positive* impressions can be obtained.

We would suggest to the publisher, the importance of selecting, for the future numbers of his 'Album', views which have an interest beyond their mere pictorial beauty. Our cathedrals, abbeys and castles furnish charming subjects for the photographic artist, and these every lover of English history would desire to possess in that truthfulness which photography ensures.

That passage, while providing an interesting description of the waxed paper process, is hardly very well conceived, praising (as it does towards the end) the photographic process which is sharply criticised for its lack of truthfulness at the beginning. However, in this as several other accounts of British photography in the *Illustrated London News*, the conclusion that the writers of these pieces had little respect for Fenton and his contemporaries is hard to escape. Later on in 1852, in an issue towards the end of December, the second volume of the *Album* is sharply contrasted with a

French publication by Maxime du Camp.

A word on the purely photographic merits of the two publications. The Parisian photographs are distinguished by a much more perfect knowledge of the capabilities, and of the difficulties of photography than those in the English 'Album'. In the first, there is strength, decision of outline, and a perfection of details, which we cannot discover in the latter.... Here and there we have evidence of those imperfections which yet cling to photography, and which can only be removed by the most searching examination into the causes in operation to produce its primary phenomena. In the photographs of Fenton and Delamotte these are much more glaring.... The uniform colour of the French photographs adds much to their perfection; this is, we believe, attained by the use of neutral chloride of gold, after the ordinary process of fixing has been gone through....

So, in December 1852, Roger Fenton was not finding a good reception for his pictures in at least one publication. It is interesting to note, too, that he had not yet adopted the practise of toning his pictures. The warm brown colour of toned prints proved much more acceptable to a discerning public and certainly by the time of the Crimean War, as can be read in his letters home, he was following the trend.

But even the *Illustrated London News* could change its mind and on many occasions later in his career Fenton's pictures found their way into those hallowed pages in the form of engravings.

Before that opening night of the photographic exhibition, Fenton and Charles Vignoles had travelled to London from Kiev. Vignoles, an engineer, had been engaged in the construction of a bridge over the River Dnieper at Kiev, and his close friend and fellow calotypist, Roger Fenton, was with him to take photographs.* The series Fenton brought back with him, all taken with Gustave le Gray's wax paper process, contains some of his finest achievements. The pictures of the Kremlin buildings and towers, especially the famous *Cathedral of the Resurrection, Kremlin, Moscow*, earned for him recognition as the finest exponent of le Gray's process.

At about the same time as Fenton was first becoming interested in photography, Charles Wheatstone was conducting experiments in stereoscopic, or binocular vision. Wheatstone was one of the first to develop the theories

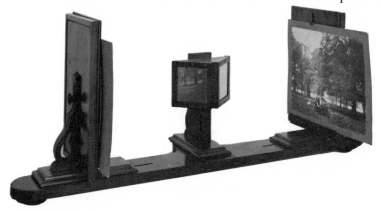

Wheatstone's reflecting stereoscope.

*To the best of this writer's knowledge the remaining examples of Fenton's photography from this expedition represent the earliest surviving examples of his work – and considering that he is reputed to have gone there primarily to photograph Vignole's work, the bridge does not appear in many photographs. There was general concern at the time about the fading of calotypes and, as a result, most were carefully preserved in albums. Thanks to that precaution, a surprising number of these early examples of Fenton's work still remain today.

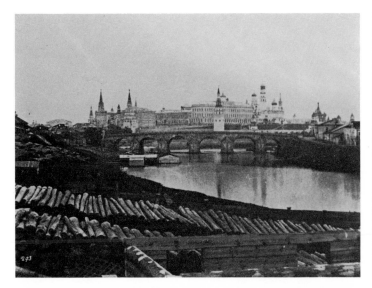

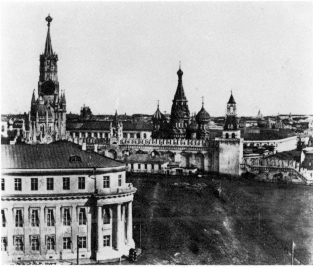

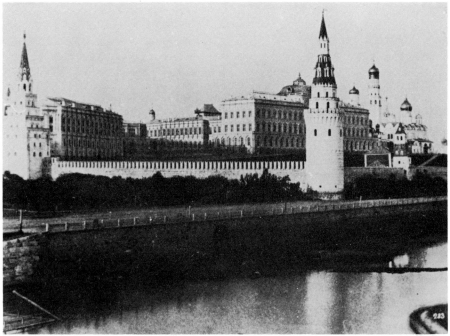

Above left: Old Bridge over the Moskwa, and the Kremlin.

Above right: Little Palace of the Kremlin, St Vasili's Church outside the walls.

Left: South West Corner of the Kremlin from the Old Bridge.

of stereoscopic vision – to appreciate that the three-dimensional appearance of objects which we see with our eyes is due to the fact that our two eyes each see a slightly different image. It was then a logical step for the experimenter to attempt to obtain, by viewing, a three dimensional impression from two correctly drawn and slightly different two-dimensional representations of the object.

Before Fenton left for Russia in 1852 Wheatstone had for some time been conducting experiments with photographs in his stereoscopic viewers, and it is probable that Fenton was entrusted with the task of providing further examples of the art. Certainly two pairs of pictures survive from that endeavour, both taken on the way from Kiev to Moscow. Both are about 9-by-7-inches in size and therefore of correct dimensions for Wheatstone's

Above: Russian Cottage. One of a stereoscopic pair produced for use with Wheatstone's reflecting stereoscope.

Left: Russian Post House. One of a pair of stereoscopic pictures, once again for the reflecting stereoscope.

original Reflecting Stereoscope. This was an ingenious arrangement whereby, with the aid of two mirrors at right angles to each other, the viewer observed the photographs which were at right angles to him and facing each other. The system required the viewer to place his eyes as close to the mirrors as possible – which meant that his nose was against the front edges of the two mirrors. He then saw the reflected images of the two photographs, one through each mirror. Each mirror was at an angle of forty-five degrees to the photograph it reflected.

However, as we shall see, this rather large stereo viewer was not the device which would achieve great popularity. The introduction of the small stereoscope with its compact sets of view cards was the beginning of a craze which, although short-lived, produced a mass of photography and a huge industry almost overnight.

Just over a week after the inaugural meeting of the Photographic Society had taken place, the exhibition at the Society of Arts closed its doors. On account of the enormous interest it had generated, it had overrun its original schedule by a month. The 800 photographs which had been on view during the thirty-eight day exhibition had brought to the public notice the work of almost every major photographer in Britain and had acted as a shop-window for almost every process then available–with the exception of the daguerreotype which, by that time, was used only for professional portraiture in Britain.

With the Photographic Society only two months old, the first issue of the *Photographic Journal* was published, carrying in its pages Fenton's paper which detailed the work which had gone into the Society's formation.

It is probable that at this time Fenton was still an amateur as far as photography was concerned. There is little evidence to suggest that he was working professionally until 1854 and the Russian trip can easily be explained by virtue of his close friendship with Vignoles. It is interesting to note that most of the legal records and law lists show Fenton's name every year from 1853 to 1864 suggesting perhaps that he never formally abandoned the practise of law.

Chapter 3

Victoria and Albert

IT IS NOT CLEAR just when Fenton became acquainted with the Queen and Prince Consort, but they appear to have met well before the Photographic Society's first exhibition—which opened in January 1854. Certainly they had met on at least one occasion before that time—when Fenton had gained for the Society the Royal Patronage of Queen Victoria herself. The Queen's first act as the Patron of the Society was to visit the exhibition on 3 January 1854. Of the visit, she wrote in her Journal:

'...at 10 we went up to London, well wrapped up in furs, and drove at once to Suffolk Street to visit the Photographic Exhibition, Sir C. Eastlake meeting us there. It was most interesting and there are three rooms full of the most beautiful specimens, some from France and Germany, and many by amateurs. Mr Fenton, who belongs to the Society, explained everything and there were many beautiful photographs done by him. Profr Wheatstone, the inventor of the stereoscope, was also there. Some of the landscapes were exquisite and many admirable portraits. A set of photos of the animals at the Zoological Gardens by Don Juan, 2nd son of Don Carlos, are almost the finest of all the specimens...'

January and February 1854 were very busy months for Fenton—he appears to have spent a great deal of time at the Palace photographing the royal children and setting up a darkroom at Windsor with Prince Albert who was a keen photographer. Queen Victoria's journals first mention a photographic session on 23 January. The famous series, *The Seasons*, was produced on 4 February 1854 and at a second session which took place two days later. That second series of pictures included pictures of Prince Arthur in his 'undress uniform' and the group pictures from *The Seasons*, taken at Windsor Castle.

Also for his royal patrons, Fenton undertook to photograph the Fleet in

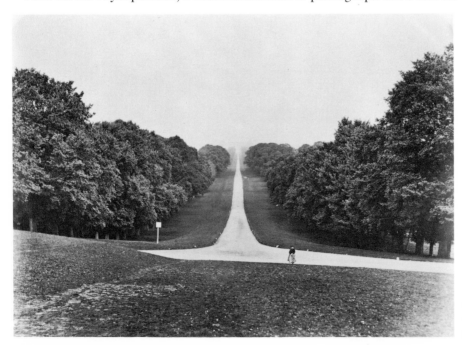

The Long Walk, Windsor—one of a series of views of Windsor Castle taken by Fenton later in his career.

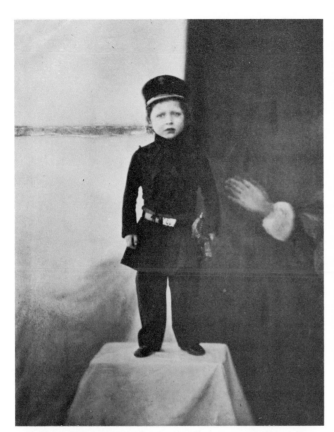

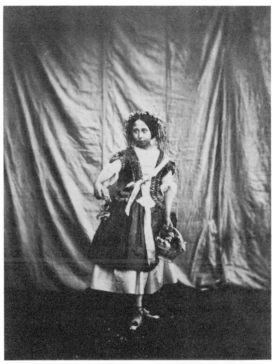

Right : Princess Alice, from *The Seasons,* 1854.

Left : Prince Arthur in the Undress Uniform of the Grenadier Guards. 1854.

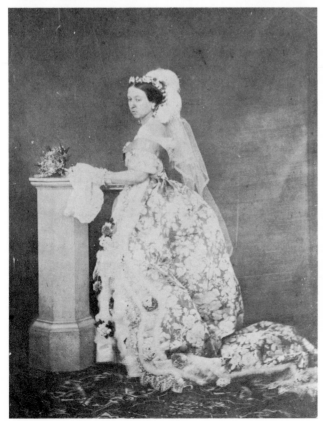

Right : Also from *The Seasons.* Prince Alfred as Autumn.

Left : Queen Victoria.

March 1854 at Spithead providing for us today a unique record of the British Navy, including the superb view of the *Victory in Harbour*.

'May 11th, Buckingham Palace We lunched early, and then dressed for the Drawing Room at St James's. Many presentations but otherwise not very full. On coming back was photographed in my Court dress by Mr Fenton, alone and with Albert, – I hope successfully . . .'

The Queen had no need to fear, for Fenton's talents produced a series of superb portraits of the Royal couple. He gave to these pictures a charm which must have more than satisfied the sitters. That 11 May visit was but one of five that month. Fenton had been employed by the Queen on the 1, 5, 6, 11, and 21 May and again in June, to photograph Lady Harriet Hamilton. By July the total amount of work produced was reaching fair proportions and, when Fenton submitted his accounts to the Privy Purse, they read as follows:

E. Becker Esqre to R. Fenton		8th July 1854		
		£	S	D
March 15th	13 copies of portraits at 1/6		19	6
11th	8 do of the Fleet at 7/6 each	3	0	0
April 10th	5 negatives taken at B.Palace	5	5	0
May 1st	8 do do	8	8	0
5th	6 do do	6	6	0
6th	10 do do	10	10	0
12th	25 positives at 1/6 each	1	17	6
13th	18 do do	1	7	0
21st	12 do do		18	0
,,	5 negatives taken at B.Palace	5	5	0
June 12th	8 do of Lady Harriet Hamilton	8	8	0
13th	17 copies of portraits at 1/6 each	1	5	6
30th	3 negatives taken at B.Palace	3	3	0
,,	8 views on the Wye and Tintern at 7/–	2	16	0
,,	7 portraits of Lady H. Hamilton at 1/6		10	6
,,	14 studies from the life at 4/– each	2	16	0
July 1st	9 large portraits at 2/– each		18	0
8th	25 do do	2	10	0
		£66	2	0*

The 'tableau' was a uniquely nineteenth century form of expression and the scenes photographed by Fenton are indeed Victorian in style and content. *The Seasons* included Princess Alice as 'Spring', the Princess Royal and Prince Arthur as 'Summer', Prince Alfred as 'Autumn' and the Prince of Wales, among others, as 'Winter'. It was but one of a series of *tableaux vivants* which Fenton was called upon to record: and another, photographed about the same time was *Les Petits Savoyards*. Several of the photographs were felt by the Queen to lack the dignity becoming the Royal children and were never released to the public. However, for us today, they all combine to give us a charming picture of the life of the Royal family a century and a quarter ago.

The Prince Consort carefully arranged all the photographs in a series of

*The cheque was in the post to him supposedly on the 7th of July – predating the invoice by one day, presumably to aid book-keeping, as the financial quarter for the Privy Purse ended on 8 July. Perhaps it was the rush with which Fenton submitted his invoice that caused him to add the figures up incorrectly. Whatever the reason, he undercharged the Privy Purse by the princely sum of one shilling as the invoice totals £66.3.0!

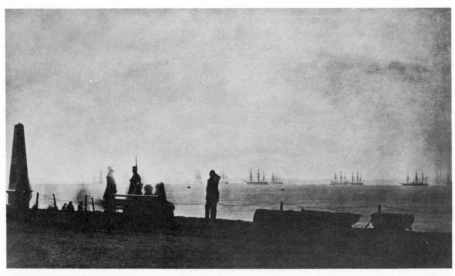

The Fleet at Anchor, 11 March 1854.

albums entitled *Calotypes, Vol I, II, III* and *Royal Children Vol I*. They were in fact calotype, or salted paper prints from wet collodion negatives. Fenton had been using collodion at least since the spring of 1853.*

It is perhaps a reflection on the Victorian attitude to the art of photography that so many photographers turned to the 'tableaux' form of picture-making. There appears to have been a feeling in the early years that straightforward photography was both limiting and unartistic. Fenton, with Prince Albert, was merely retreading the steps which David Octavius Hill and Robert Adamson had trodden ten years before in Scotland. They, in their turn, had found less of a challenge in straightforward portraiture and turned to 'dressing up'. This is something which Fenton never seems to have got out of his system – in the Crimea he could not resist the temptation to dress up as a Zouave and have Sparling take his 'likeness' – and later still his 'Nubian Slave' pictures made their appearance!

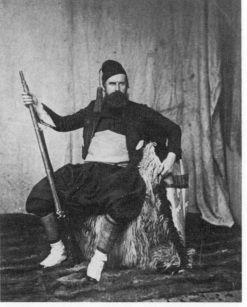

Roger Fenton, by Marcus Sparling. Titled *A Zouave, 2nd Division*, this was one of the published series of Crimean War portraits.

*It is perhaps on account of the Queen's refusal to publish, or make available, the *tableau* pictures that so many of them have been left in such good condition for us to see today. They were restricted to the pages of Albert's albums for decades thereby avoiding the fading due to constant exposure in bright light which was such a risk with calotype prints. Salted Paper was paper impregnated with common salt and then sensitised in a silver nitrate bath. It was used for printing almost exclusively from its introduction by Fox Talbot in 1840 until its replacement by albumen paper in about 1854.

Chapter 4

The British Museum

ROGER FENTON's photographic associations with the British Museum lasted for such a major proportion of his photographic career that to deal with each commission at the correct chronological moment in the sequence of this book would produce a fragmented and unsatisfactory result. The entire seven and a half years of photography for the British Museum can best be described in a single chapter. This one contract provided Fenton with work from the final years of his calotype period right through to almost the end of his photographic career.

The British Museum, thankfully, kept very precise records throughout the period and, from these, we can read of their first ideas on the formation of a photographic unit. The trustees first discussed the idea at a meeting in June 1853 and their first purchases of equipment were made in the following month. A fair-sized budget was agreed at the August meeting and, in September, the decision to appoint a photographer, on a temporary basis, was agreed. By the end of September, the studio, or 'photographic room' as it was called, was ready and the trustees decided to approach Mr Fenton for his advice on further equipment. He must have impressed them for, on the 8 October, they agreed to offer him the position of photographer. Between the end of October, when presumably Fenton replied to them, and the end of February, the museum staff, together with Fenton himself, experimented with the equipment in the studio and tried out various methods of recording the statues and prints for which the venture had been dreamed up. Fenton's appointment, for a two month period, was confirmed on 11 March 1854 and the supervision of all photographic work was made the responsibility of the Principal Librarian. The trustees of the British Museum, having had no previous experience of photography, the 'black art', had approached one of the recognised leaders of the field for advice at the outset. Their choice of adviser had been Wheatstone and it was he who had suggested Fenton for the position of photographer.

The agreement into which Fenton entered required him to provide his own chemicals, plates and papers while using the Museum's equipment. He was to provide his own staff and pay their wages while he, himself, would be paid a sum by the trustees for the work undertaken. Fenton was given a budget of £180 with which to buy the equipment he needed.

The initial experiments seem to have been highly successful–and of a high enough standard to satisfy the critical eye of the experts in the Museum. These tests appear to have been carried out by photographing Assyrian Tablets, and a report dated 9 March 1854 suggested that twenty prints be made from each negative 'and photographic impressions be sent to such scholars as are known to be engaged in their translation and interpretation, for the verification of the printed copies.' They further agreed that a minimum of five prints would be needed from each negative– three for their own records and two to be sent to any museum 'peculiarly interested' in the particular subject.

In the first weeks of his appointment, Fenton photographed a large range of subjects and the British Museum arranged to market the prints, through the Society of Arts, for distribution to provincial societies.

The original two-month contract expired in the middle of May and

Sir Henry Ellis was requested to see Fenton to discuss an extension of the contract. Fenton was, at that time, working with the collodion process and offered the trustees four different negative sizes from which to choose. These he priced at 10/–, 12/6, 15/– and one guinea each, depending on size. There is a mention in a document outlining the prices dated 13 May 1854 which states that 'none of the larger sizes have yet been tried' but that it had been found necessary to introduce a fifth negative size between the smallest and the next to smallest and this would cost 11/–. Prints from the original four sizes cost 1/–, 1/3, 1/6 and 2/6 and the cost of a print from the new negative size was to be 1/–. The same report told of a staff of four working for Fenton exclusively concerned with printing for the museum. The first month's work brought Fenton in a total of forty-eight pounds and the second month brought in about one hundred pounds. The print costs alone amounted to ten pounds per week and it was suggested that this might have been higher if the weather had been better. When you consider that many a studio today will still take a photograph and print it for less than a pound, then the true scale of Fenton's charges one hundred and twenty years ago can be appreciated.

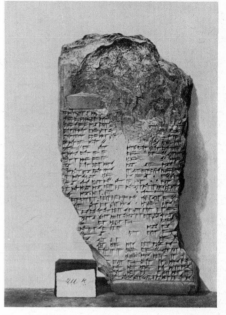

Inscribed Tablet No 211K. One of Fenton's earlier works for the Museum.

The contract was extended for a further two months and came to an end on the 11 July 1854. By that time the total cost of employing Fenton had risen to £283 with at least one account outstanding. The budget for the entire project had been set at £250 so, with the final account still to be presented by Fenton, the museum had overspent by thirty-three pounds. Work was suspended in the photographic room; Fenton left the premises and the trustees appear to have lived through a short period when no-one felt qualified to report on what, exactly, was going on in the studio.

Unfortunately, we here come to a gap in the otherwise perfect records of the museum. No mention appears of Roger Fenton's reappointment and the next entry concerns his accounts some fourteen months later. However, a letter remains, dated 9 November 1854, which gives a good idea of the scale of the undertaking. It is from Augustus Franks, the accountant who was responsible for holding on to the purse strings of the photographic room and it is addressed to Edward Hawkins, the museum's secretary.

Department of Antiquities
9th November 1854

Dear Mr Hawkins,

The principal points which have to be considered with regards to the photographic department appear to me to be the following. 1. The amount of work completed during the last year. 2. The best mode of disposing of the photographs so produced. 3. What work will have to be done during next year.

The photographic operations in our department during the past year may be divided into two two branches: 'Assyrian Tablets' and 'Miscellaneous antiquities: acquired during the year'.

Assyrian Tablets We have received from Mr Fenton twenty impressions from 181 photographic plates forming 3,620 pictures. On these are

represented both sides (where they are inscribed) of 128 tablets. A considerable number of negatives have been made from other tablets which have not as yet been printed off and which make the whole number of tablets which have been transferred to glass to amount to 200. About 50 of these have been made by Mr Fenton at his own risk and without any prospect of immediate payment in order to avail himself of some very favourable weather which occurred after the order had been given to discontinue operations.

The sum expended on this branch, including the present account is £283.18.0.

Miscellaneous Antiquities Under this head are comprised photographs from recent acquisitions made with the view to forming a photographic register of the acquisitions of the Department. They consist of 99 plates from which 519 Photographic Pictures have been obtained. The sum expended on this branch has been £34.18.6 including the present account.

I should mention that owing to the importance of proceeding with the Assyrian Inscriptions, the Photographic Register has not been made complete and that considerable arrears remain to be done.

The above items make the whole sum expended on Photographic Pictures to amount to £368.16.6 besides £10 which was paid for preliminary experiments.

In the above estimate I have included the sum still due to Mr Fenton for work already delivered amounting to £99.5s.3d of which the annexed account will furnish you with the items. The museum is further indebted to Mr Fenton between £10 and £15 for negatives which have been made but not yet printed off or only partially so. Unless the photography is to be entirely discontinued or the Trustees do not intend to avail themselves further of Mr Fenton's services it appears to me that it would be desirable, instead of the exact sum due, to pay Mr Fenton £10.0.0 on account. By this arrangement Mr Fenton would be responsible for any accidents which might occur to the negatives while they are being printed off. I should mention that this sum only includes such negatives as were made before the Trustees issued their order to discontinue Photographic operations for the Present.

The next point for consideration is the disposal of the photographic prints which have been received.

According to the desire of the Trustees I have selected four sets of the Tablets for Col. Rawlinson, Dr Hinchs [?], Mr Layard and the University of Bonn. They have not however been forwarded to the Secretary's office for two reasons, one, that owing to an accident which happened to one of the negatives the proper number of one side of one of the tablets is not ready. Mr Fenton has made a fresh negative and I am daily expecting the missing prints. The other reason is that no form has yet been fixed upon which the tablets are to be issued and that it is not desirable to lay them down till such a form has been decided upon. The set which was submitted to the trustees was made merely for the use of the department as an index to the tablets and was not prepared

with that care that should be bestowed on the sets to be distributed to learned persons or bodies.

It appears to me very desirable that after so much has been expended upon the photographic pictures they should be issued in a form creditable to the museum. I would therefore suggest that a short introduction and title page should be prepared by Mr Vaux giving an account of the objects represented, the reasons which have induced the trustees to issue them in that form and such other observations as may be deemed necessary. Each tablet should then be fixed down to a separate leaf to enable them to be rearranged or compared by the students in cuneiform character and for the same reason they should be enclosed in a stiff loose wrapper. Should it be decided to issue the first hundred separately, they might be labelled[Assyrian] Tablets Part 1.

With regard to the persons to whom they are to be distributed I would recommend that such only should be selected who are known to be studying in earnest this branch of antiquities and not merely to public libraries or institutions. The enclosed list has been furnished me by Mr Vaux as of persons who would make real use of the photographs. These restrictions appear to be the more necessary as I have always understood that it is the intention of the trustees at some future time to publish these inscriptions in another form and that they have been photographed with the view of placing in the hands of students without delay the materials for the study of the cuneiform character entrusted to our keeping.

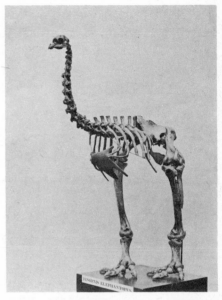

Dinornis Elephantopus. One of the stranger pictures produced during Fenton's long association with the British Museum.

Of the photographs from the recent acquisitions from five to six copies have been taken. One of these is intended for a photographic register arranged according to the date of the acquisition, a second is intended to form part of an illustrated catalogue. The other three have been done to exchange with such foreign museums as may adopt a similar practice. A sixth copy has in some cases been taken of such works of art as would prove of use to the Department of Science and Art at Marlborough House. The Offices of that Institution having expressed a wish to make arrangements with the museum for procuring such photographs either by purchase or exchange. A sixth copy has likewise been made of the photographs from Mr Newton's pottery which it would be desirable should be given to Mr Newton in order that he may know the forms and decorations of the vases which he has sent to us so as to prevent the accumulation of duplicates. It would also be, I think, very desirable that Mr Newton should have photographs of such other Greek antiquities as may from time to time be acquired that he may be kept informed of the state and requirements of our collection.

The third point which appears to need consideration is the photographic estimates which have to be made for the financial year 1855–6 with a view to preparing the parliamentary estimates for that year.

The fragments of Assyrian tablets are, as you are aware, very numerous. I am informed by Mr Vaux that from 350 to 400 of them are worthy of being photographed. Of this number 128 have been already completed and from 222 to 272 remain to be done. The cost of the first

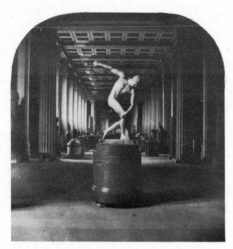

A Discobolus from Hadrian's Villa, Tivoli. This stereoscopic pair was published in the *Stereoscopic Magazine* some time after Fenton photographed the same subject for the trustees. The number of published stereos which match up with the large format views would seem to suggest that Fenton produced stereo copies of most of his photographs and filed these for his own use at a later date.

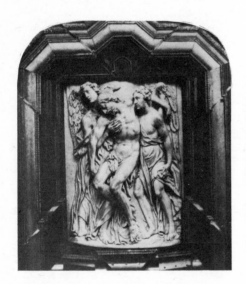 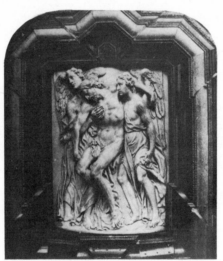

Jesus Sustained by Angels.

Elgin Marbles – one of three views of the Greek sculptures which were published as the entire content of one month's *Stereoscopic Magazine*.

hundred tablets has been about £215 it would therefore require from £475 to £575 more to complete the whole.

Mr Fenton has however stated to me that he is willing to undertake to do the whole or the greater part of this number at a lower rate than the present one on condition that such a number is to be paid for within a given time. This he would be able to do from the sameness of the work which would require few shiftings of lenses and therefore take less time than the other objects.

The principal point to be decided with regard to the Assyrian tablets is how many are to be photographed and in what time.

Not less than £300 should be devoted to photographs from other antiquities as considerable arrears remain to be done from the present year. The continuation of the photographic register appears to be very important as it will enable us to identify our antiquities with certainty if lost or mislaid or as sometimes happens, the registration mark should be obliterated.

I believe however that by preserving the negatives of the better class of acquisitions some alleviation might be found to the expenses of the photographic department. Several inquiries have been made by persons desirous of purchasing photographs and by fixing a moderate price a sufficient number of copies might be disposed of to reduce the first expense of the negatives. There would not of course be any great demand for them during the first year which will necessitate a larger grant for that year than might be required for succeeding years. You will perhaps allow me to make some observations on this point at greater length on some subsequent occasion.

There is but one other thing which appears of importance in connexion with next year's grant and that is that the sum fixed upon shall be appropriated to the work of this department alone and that a separate grant should be made to any other department who may require one.

In conclusion I think I ought to state that Mr Fenton is very anxious that the trustees should make definite arrangements with regards to his services for the coming year. At present his printing establishment is on a larger scale than would be required for his own work, and he is unwilling to discharge the men he employs there if the trustees intend to proceed with photographic operations as it would take some months to train fresh workmen satisfactorily.

I must also add that I have uniformly found Mr Fenton very careful and very anxious that the negatives and positives which he has produced should be well and satisfactorily executed, even at the loss of a great deal of time to himself.

> Believe me to be
> Yours faithfully,
> Augustus M. Franks.
> to Edward Hawkins Esq.

And surely we would expect no less care from Mr Fenton! With an income approaching nine hundred pounds per year from this one source alone,

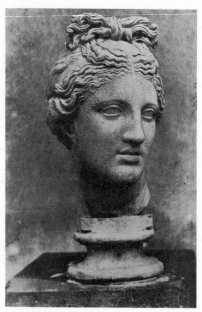

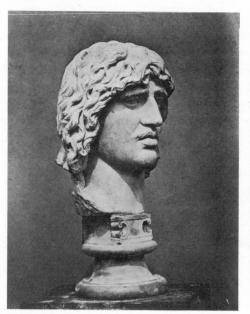

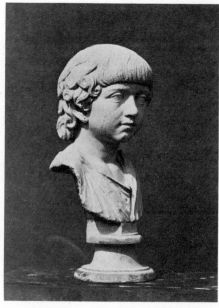

Photogalvanographic engraving from an untitled statue. It is uncertain exactly when Fenton took this picture but the engraving was published c.1856.

Head of Barbarian Captive.

Portrait of a Roman Boy, Knight Collection, British Museum, 1 ft 4½ ins high.

Mr Fenton's business was a guaranteed success.

It would certainly appear from that letter that, although nothing was documented by the otherwise careful and precise staff of the museum, Roger Fenton was still very much on their payroll. The next mention of his name concerns an inquiry into his accounts some two years later and the only possible reason for this gap can be that Fenton's work for the museum proceeded smoothly during that time without any reason for reference to the trustees being necessary. The account which warranted investigation in December 1856 was a fairly substantial one – it amounted in total to £116.14.0 and it appears that the trustees were not certain that the entire amount was due. The particular assignment to which the payment related was for the production of photographs from a large number of sketches by the Old Masters. Fenton had received a considerable amount of money in fees about that time and the librarian, although he did not exactly say so, felt that the outstanding total should be rather less than invoiced. Unfortunately, the outcome of the enquiry was not recorded.

An entry dated 1 August 1857 included a letter from Fenton concerning the next job for the museum – the continuation of photography of statues and friezes. Mr Fenton reported that he had, by 30 July, photographed some thirteen statues and busts all of which had been photographed out of doors. The assignment under consideration at that time concerned a further number of statues and the first 'batch' of the famous Elgin Marbles. In this letter Fenton makes the first of his 'offers' to the trustees. Being a shrewd business-man, he saw the commercial possibilities of good photographs of some of the museum's treasures and was quick to suggest to them that, if he could use the negatives for his own purposes after the required number of prints for the museum had been produced, he would take the

original negatives at a reduced cost. He also offered to cut the price for photographs taken within the museum rather than outside in the sunlight. (His exact fee structure can be appreciated from the letter printed below).

His offer and the terms were still under consideration in November when he produced prints of sculptured heads from Budrum for the approval of the Board.

> 2 Albert Terrace
> Albert Road
> Regents Park NW
> Oct 24/57

Dear Sirs,

I find on my return to town a note from you requesting me to state the terms upon which I propose to take photographs of the antique statues and busts in the B Museum.

The plan which I propose is one which I mentioned to you in conversation some time since and refers not only to the statues, but to other objects of art in the Museum, such as Drawings of the Old Masters.

It is as follows:

'I will take the negatives without payment and will print for the trustees as many copies of each negative as they may require—at the usual price which I charge for printing provided the trustees order not less than 100 copies of each negative and allow the negative afterwards to become my own property.

The price now paid for negatives such as these of the antique statues, 15 inches square is £2.2s if the objects are brought on to the leads near the photographic room—4 gns if taken in a walled building. The prints cost £10 per 100 or 2s each.

I have taken of the statues about 30 negatives some of them being views of the same object from different points of view.

> I am, yours very truly,
> Roger Fenton.

On several occasions in reading Fenton's letters, this dual fee structure is apparent. The 'leads' referred to was a flat area of roof near the photographic studio in the museum and common practise appears to have involved carrying the statue to be photographed through a nearby window and out on to the roof where the photographer could simplify his task by using bright sunlight. The dimmer halls of the museum itself obviously required more work, more risk and usually a greater expense in trial exposures. The thirty or so negatives already taken at the time of writing that letter were listed in a letter he had written in July of 1857. The list reads like a *Who's Who* of classical sculpture including statues of Homer, Apollo, Venus, Diana and others. In taking these photographs Roger Fenton had hit upon the idea of softening the appearance of the statues by dusting them with dry clay powder thus removing the harsh highlights which were always the result of photographing polished surfaces in bright sunlight. He was so pleased with the results that he begged the trustees to allow him to take all future pictures of statues on the roof, rather than using

the uneven overhead lighting of the roof windows in the museum galleries.

At first the trustees did not totally agree with his scheme. The first photographic project of 1858 was the production of negatives of a series of Durer carvings, and the best deal Fenton could get was permission to produce fifty copies of each for his own use. However, by the end of January permission had been given for him to put his plan into operation. He reserved the right, however, to decline ownership of the negative if it was of no commercial value to him and he invoiced the trustees accordingly. The spring of 1858 brought commissions to photograph stuffed animals and animal skeletons and these had little public appeal. Many other more interesting subjects were presented to him however and, by the end of July, he had, with the permission of the trustees, erected a sales point in the museum for selling his prints to the general public.

The prints produced from Fenton's negatives were now being sold through a number of channels. The official British Museum prints were sold through the London print publishing house of Colnaghi, and Fenton's pictures were sold either by his staff at the museum or through de la Rue's. The permission to allow Fenton to sell on the premises had been granted only for a trial period, but the practise appears to have continued almost to the end of the year.

About this time a circular was issued by the Science and Art Department which was really the beginning of the end for Fenton at the British Museum. The use of photography had expanded beyond recognition during Fenton's years of work for them. When he was appointed to start his sixth season for them—most of his photography was completed in the spring of each year—government officials were determined to rationalise the expenditure on photography in London's museums. Information is not very great on the subject but the plan appears to have involved reversing Fenton's payment structure—i.e. paying him for the negatives and arranging for the production of prints and the sale of mounted prints to be taken over exclusively by the South Kensington Museum. The suggested fee was 2 guineas per negative with Fenton abdicating all claims to the negative on payment.

Fenton heard about this in the late spring of 1858 and wrote a long and detailed letter to the museum in June making his position quite clear. He pointed out, quite reasonably, that the print is best made by the photographer himself—the point was laboured at great length with Fenton going into great detail over the skills, both artistic and technical, required in the production of a good picture. It appears that the South Kensington Museum had a staff of sappers who had been ordered to learn photography, and Fenton was adamant about not allowing his negatives to fall into 'such hands'. At two guineas per negative there is little doubt that Fenton's income from the project would have been decimated: it was from the prints that he made his money. He did go to the museum to try and thrash the problem out with the trustees but he failed to convince them. The very next entry, after his letter, concerns a decision by the trustees to pay compensation to him for his interests in the photographic room and his loss of immediate earnings. A figure of one hundred guineas was agreed and by the

beginning of August all his outstanding invoices, together with the compensation payment, had been met in full.

That was not Roger Fenton's last work for the museum however, as a Mr Reeve was permitted by the trustees to employ him for a series of photographs in 1860. These were taken towards the end of October 1860 and the reference to them constitutes the last entry in the records.

It is interesting to note the increase in Fenton's fee structure over the six year period from the ten shillings to one guinea of 1854 without apparent restriction as to where the picture was taken, to the two guineas outside or four guineas inside of 1858 is a large jump. His profits from the undertaking must have been high. He was selling prints to the museum at two shillings each but, for his own profit, selling prints to de la Rue for eight shillings. The large income from print runs, which in 1858 sometimes numbered thousands, together with his high initial charges for the negatives must have ensured a handsome return, in spite of having at least four printers to pay. In one letter to the museum a great deal of space is given over to details of the total gross cost of running his business. He estimated the total costs of keeping his printing establishment in operation at £250 per year. In the same letter mention is made of budgets from the Museum approaching £1000 a year. That £250 appears rather insignificant when consideration is given to the fact that the income from the museum kept his business running for the remainder of the year – even without further work!

 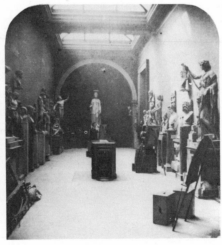

The Graeco-Roman Salon, British Museum – the Stereoscopic version of the view published in the plate section of this book.

Chapter 5
To the Crimea

AS WE HAVE SEEN in the preceding account of Roger Fenton's work for the British Museum he was an early user of the wet collodion process invented by Frederick Scott Archer.

Photography in the early days was dominated by showmen of one sort or another. There was Daguerre, the flamboyant Frenchman who attempted to sell his invention to the nation–not satisfied merely with wealth, he wanted fame as well. Fox Talbot, the calotype inventor not only wanted recognition and financial reward for his own inventions but also for everybody else's. By taking out extensive patents he attempted to personally direct and control photography in Britain.

The 'Black Art' was due for the emergence of a figure so completely opposite to those two, and in 1851, in the shape of Frederick Scott Archer, that figure appeared. He was a quiet man, unimpressed by patents, fame or glory. In fact he gave away his invention to everyone and anyone who would use it. The effect of this generous gesture was two-fold. Although Archer was unaware of the fact at the time, his gift would ensure that photography would at last be able to free itself from the restrictions of the preceding years and advance both in stature and popularity. Secondly, it also ensured that Archer would die in poverty and never really achieve his rightful position in photographic history. History often appreciates the exhibitionist and under-rates the quiet genius.

Archer was the son of a Hertfordshire butcher and was apprenticed to a London silversmith at a very early age, becoming both an interested and dedicated craftsman. He was an ambitious man and worked hard to improve his position, despite poor health. Luckily his doctor was Dr Hugh Diamond, a keen amateur photographer and calotypist. At the time the two met Archer was becoming interested in sculpture, and Diamond saw the potential of using the photographic process to help Archer in his modelling. The silversmith-turned-sculptor soon became very interested in photography and, equally quickly, very dissatisfied with the process which Diamond had taught him. By 1848 the inadequacies of the process– and especially the intrusion of the paper texture into every picture–caused Archer to turn his attention to the chemistry of the process in the hope of producing a better image. Not surprisingly his early researches took the form of trying to find a substitute base for Talbot's calotype emulsion.

It was only in 1846 that the word 'collodion' was introduced for the first time by two scientists. They had found the substance almost by accident when they dissolved guncotton in a suitable solvent. The resultant sticky mass dried out to form a clear film, which soon found many uses in medicine as a simple dressing for wounds and operation scars.

Archer's original experiments with this compound were limited to attempts to coat the calotype emulsion on to prepared sheets of collodion film, but these proved fruitless as the adhesion was too poor to be viable. His first successes came in 1849 when he incorporated the emulsion in the collodion itself and coated the compound onto glass. Here at last was the perfect base–clear, strong and totally transparent. Initial experiments with the collodion emulsion proved that, if the emulsion was allowed to dry, the sensitivity became markedly less; so Archer tried using it wet. The results

were highly successful and the 'wet-plate' process was born.

The method of manufacture was simple – potassium iodide was dissolved in the collodion and coated on to the cleaned glass sheet. The result – greater sensitivity to light than had ever been known before. The plate was sensitised in silver nitrate solution (the nitrate bath to which Fenton refers so often) just before exposure, and loaded into the camera while still damp. The only problem was the coating – the emulsion had to be poured on to the centre of the plate and the plate carefully tilted in every direction until a perfectly even coating was achieved. The correct working of the plate depended on the evenness of the coating. The still damp plate was removed from the camera immediately after exposure, developed in a solution of pyrrogallic acid and fixed in hypo. The length of time available to the photographer for all this work of preparation, exposure and development was short indeed. In hot climates, as we shall see, it was even shorter. The solvent used to dissolve the guncotton was ether – which literally evaporated before the photographer's eyes!

The process had many drawbacks as well as many advantages. The advantages of high emulsion speed and finer image texture were balanced by the need for the outdoor photographer to carry a portable darkroom with him wherever he went. He needed to carry large stocks of heavy glass plates and chemicals as well. He had to pose his figures in the picture and then retire for a few minutes to prepare his plate, hoping that no-one would move!

When it was announced to the public in 1851 the greatest advantage of the process appeared to be its freedom from all Talbot's patent restrictions. Gustave le Gray's wax paper process, a modified calotype process, also should have been free of patents, but Talbot claimed control of its use, and many photographers paid up to avoid trouble.*

Fenton's experiments with the collodion process had been under way long before the advent of the Crimean campaign. As far back as the end of 1853 he had presented a paper to the Photographic Society on his observations regarding the 'nitrate bath' – the solution of silver nitrate in which the collodion plate was sensitised just before exposure. That paper started with the statement that 'every photographer complains of the uncertainty attending the production of collodion pictures' and went on to add that 'It occasionally happens that when complaining of the occurrence of such disappointments, one hears a neighbour say, "Oh, I find no difficulty in it"...' – And that was exactly what happened during the discussion which followed the reading of the paper.

In his paper he described how two photographs taken under apparently identical conditions could yield totally opposite results and commented that 'there is, however, yet another cause of failure' (in addition to dirty plates, badly prepared collodion and many other reasons which he had previously cited) 'and one which produces results the most striking of all – the differing condition of the nitrate of silver bath.' His paper continued:

The best method I can find of illustrating this, is to describe the ordinary course of a day's work.

*Fenton used the wax paper process from his earliest days as a professional photographer until some time towards the end of 1853, when he turned to the new glass plates. He used his assignments at the British Museum to try out the process, probably covering the jobs on waxed paper to ensure that he was never left without a record of a particular subject. It was the fact that he had experimented with the wet collodion process which ensured his selection as photographer for the semi-official photographic expedition to the Crimean War, under the auspices of Thomas Agnew.

We will suppose the collodion employed be of average sentiveness and tenacity and the exciting bath to be the usual one of 30 grs. of nitrate of silver to the ounce of water in which a little iodide of silver has been dissolved.

We will suppose too, that the temperature of the room and of the bath in which the plate is rendered sensitive remains at about 60°.

The first picture produced, which has been exposed in the camera for what is deemed a suitable time will most probably turn out rather feeble in its development. It will be very clear and transparent in the shadows, perhaps vigorous enough in the highlights but wanting in half tones. The next picture receives a longer exposure in the camera and produces a satisfactory result. The third, with the same exposure, is perhaps a little more brilliant and is developing rather more rapidly. In the succeeding pictures you are surprised to find that your collodion is apparently becoming more sensitive, and that the length of exposure to light must be progressively reduced. At last, if working with a double lens, it is scarcely possible to have too short a continuance of the action of light.

The operator now determines to do something wonderful, and resolves to arrest and congeal, for the admiration of the outer world, some of those 'nods and becks and wreathed smiles' that play over the face of female or infantine beauty, like the light airs of summer on a quiet lake. He is much to be pitied if he does not know how to meet with some such good photographic studies to practise upon. Having prepared his plate and seized in the very nick of time a happy attitude or a delicious expression, he hurries to the developing room and reveals in the foretaste of anticipated enjoyment. Scarcely, however, has the picture begun to appear, eclipsing expectation with its surpassing beauty, than it darkens all over, and is gradually hidden behind a thick shroud of blackness.

After having enjoyed this vivid experience of the fact that photography, like everything else under the sun, is vanity and vexation to the spirit, the operator will next endeavour to ascertain the causes of the phenomena which have thus been successively presented.

Of this enquiry, the first step is to acquire an exact knowledge of the condition of the nitrate bath at the commencement of its use, and then to ascertain the change which it generally undergoes.

It will be found that a bath composed of crystallized nitrate of silver, almost invariably contains a little free nitric acid, the effect of which is to retard not only the development of the image produced upon the sensitive plate but also, I believe its formation.

On testing the bath with litmus paper, after a few plates have been rendered sensitive in it, the excess of acid previously observed is found sensibly diminished, or it has entirely disappeared. If the bath be constantly used until the plates excited in it blacken all over under the application of pyrogallic acid, and be then once more tested, it will be found to have acquired an alkaline condition.

I have always found that the greatest sensitiveness is produced by a

bath as nearly neutral as I could get it. In confirmation of my own experience, I am informed by a Member of this Society that when anxious to produce a very rapid impression, he makes use of fused nitrate, from which all the free acid has been expelled by heat.

These observations are in apparent contradiction to some remarks, made in a paper communicated some time since to the Journal of this Society, by one of its most efficient members. In that paper, it is recommended to add to the collodion a little ammonia in order to increase its sensitiveness.

The contradiction, however, is only apparent; for if the bath be in an acid state, as when newly made it generally is, a collodion slightly alkaline would be likely to produce a surface in that neutral condition which appears to accompany the production of the most successful results.

The excess of alkali which is sufficient to destroy the negative picture is exceedingly minute. In endeavouring to restore the neutral condition of a bath containing 40 oz of liquid, I have sometimes found that a single drop of nitric acid is too much.

. This fact has also been observed by other members of this Society, and especially by Mr Hocken.

By diluting very greatly a drop of acid, it is easy to measure off such a fraction of it as, by experiment, shall be found sufficient for the required end. Practically, however, the addition of a little fresh nitrate of silver will produce the same result.

During the past spring, when engaged in the reproduction of landscapes by means of collodion, frequently, in order to warm the bath, I exposed the bottle which contained it, where no fire was at hand, to the rays of the sun. The bath, was an old one and, as such, rather alkaline than acid. After such exposure the first few pictures produced were ordinarily very successful, being brilliant and clear in the transparent parts. This I attributed, and no doubt in part correctly, to the whiteness of the morning light. It must, however, have also been due to the precipitation of a small portion of silver by the action of light and the consequent liberation of nitric acid.

If at the close of a day's work the bath begins to show signs of an alkaline condition, it is generally restored to working order, by exposing it for a short time to the sun's rays before making use of it, the next morning . . .

A discussion followed the reading of the paper in which many of the leading lights of the Society participated. Surprisingly, although he was present, Scott Archer said nothing, leaving the discussion to Fenton, Diamond and others.

One interesting feature which emerges from the reading of the report of that discussion is the difference between the wet collodion process as it was then in use, and Archer's original conception of it. This is shown in a comment made by an unnamed member who said: 'When Mr Archer first published his paper, the process which he made known was that of taking

the collodion off the plate, and in order to do that, the layer was of considerable thickness and tenacity.' Thus in the original process the glass appears to have been used in the preparation of a film base rather than as a base itself.

Curiously, despite Fenton's conviction that the problem he was encountering would be one of interest to other users – who must obviously, he felt, have encountered it themselves, the general reaction of the meeting appears to have been surprise that he was having so much trouble with so simple a process. In fact Mr Berger was quite categorical in his dismissal of the whole problem: 'I have had a bath which has been in use for at least three years' he said 'and I have never met with the difficulty which has been alluded to by Mr Fenton.' He did concede, however, that he 'topped up' the bath with fresh silver nitrate while still asserting that the strict controls, advocated by Fenton, on the acidity or alkalinity of the bath, were quite unnecessary.

One can assume that the problems were there – or Fenton would have had little to talk about. It is interesting to see from this meeting how the chemically unqualified users of the process broadened their knowledge and skills by experiment and by a sharing of knowledge which was truly in the spirit of Fenton's original ideas for the Society.

Fenton is, more often than not, referred to as being the first war photographer. That honour does not belong to him however, but to Karl Baptist von Szathmari who photographed the 'dress rehearsal' for the Crimean War when the Russian troops invaded Wallachia and Moldavia at the beginning of the Russo-Turkish wars. Only one known record of Szathmari's work remains – in the form of an engraving made from his photograph of Prince Goreschakoff, the Commander-in-Chief of the Russian forces in the Crimea, which appeared in the *Illustrated London News*.

The first photographer actually in the Crimea was an employee of the British Government, a gentleman by the name of Richard Nicklin who had been employed by the New Bond Street photographic concern of Dickinson and Co. For six shillings a day Nicklin and two assistants arrived at Varna on the Black Sea in June 1854 and took a number of photographs from the deck of the *Hecla*, the same ship which would bring Fenton to the seat of the war. The trio were due to return home on another ship when, off Balaclava, a hurricane sent the ship to the bottom. Nicklin and his two assistants were presumed lost with all their pictures and equipment.

Still eager to get photographs of the war to allay fears at home that conditions for the British troops were atrocious, the War Office hastily trained two soldiers, Ensigns Brandon and Dawson, and dispatched them in the spring of 1855. This pair actually completed their task and returned home. Their photographs were lodged in the War Office and for some reason or other – perhaps due to their inexperience and lack of understanding of the processes involved – the pictures faded rapidly. By 1869 they were described as being in an atrocious condition and, one presumes, were subsequently destroyed. Certainly recent researches have failed to reveal their whereabouts.

Thomas Agnew, the Manchester publisher, was approached with the idea of a joint venture into the Crimea. Under semi-official patronage, Agnew was to send a photographer to the war and produce a series of pictures for subsequent sale at home, depicting the war in a way which would not unduly upset the nation as a whole. The idea was for the Government thus to obtain a definitive account of the British Army and the scenes in the battlefield and for Agnew's to gain some financial return for their enterprise. It was Thomas Agnew himself who suggested Roger Fenton for the assignment, late in 1854, on account of the photographer's recent experiments with collodion, which was felt to be the more suitable of the current processes for the job.

Fenton had several months in which to prepare himself for the task ahead and used the time to collect together the various tools of his trade and put his photographic van to the test. The van was a converted Canterbury wine merchant's carriage, which was rebuilt to provide both darkroom and living accommodation. With his two chosen assistants for the trip, Sparling and William, he set off for Yorkshire trying to simulate as closely as possible the conditions he would be likely to meet in the field. The photographs he took at that time were processed in the van, proving that his design was sound. Several of them survive today in the Royal Photographic Society Collection and include views of Rievaulx Abbey, Fountains Abbey and York Minster. Like all the material he was producing at this time, the collodion negatives were printed on to Fox Talbot's salted printing paper.

One of the last preparations consisted of acquiring letters of introduction from the Prince Consort and from the Minister of War, Lord Newcastle.

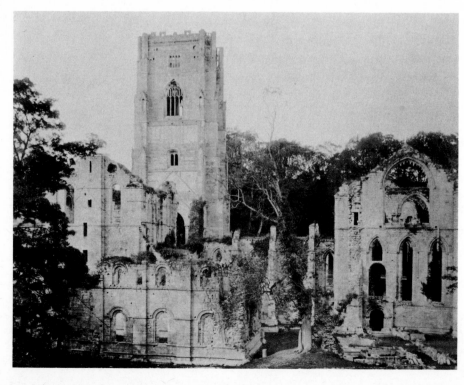

Fountains Abbey, the Great Tower. This is one of the views produced on Fenton's 'trial run' to Yorkshire in October 1854 to put the photographic van through its paces.

The British Army at the time was suffering heavy casualties, not caused by the enemy but by the conditions under which they were forced to exist in the Crimea. This forced the resignation of Lord Aberdeen's government early in February 1855, leaving Fenton with almost useless letters of introduction, but still with the blessings of Prince Albert.

He set sail on board the *Hecla* and 20 February 1855, stopping at Gibraltar to buy horses for his van and arrived at Balaklava on 8 March.

On his return to Britain he delivered his pictures to Agnew and set about the lengthy task of printing the three hundred and sixth pictures he had taken. The first prints went on sale in November 1855 and in January, at a packed meeting of the Photographic Society, he gave an account of his four months at war.

Narrative of a Photographic Trip
to the Seat of the War in the Crimea,
By ROGER FENTON *Esq*

Permit me before I commence the description of my labours in the Crimea, to thank you for the good wishes with which you accompanied me on my departure, and the kind welcome which I have received on my return.

The knowledge that I was followed by the sympathy of the members of the Society, encouraged me often, when inclined to grow weary of my task, though I must confess that it did not tend to tranquillise my nerves to think of the expectations which they might form as to the results of my labours.

I do not intend tonight to tell you merely about the modifications which were found to be necessary in our photographic work from the difference in climate, in intensity of light and elevation of temperature. These, of course, I shall have to speak of, with the hope that my experience so laid before you, may call forth that of other members of the Society, some of whom I know have practised the art in countries where the thermometer attains a higher point, and where the general character of the climate renders physical labour much more trying to the constitution than that of the Crimea. I propose to give you a sketch of the preparations I made, of the difficulties I encountered, the way that they were overcome, and of such incidents that struck me as most worthy of notice during my stay.

First then, as to the preparations. I took with me a camera for portraits fitted with one of Ross's 3-inch lenses, two cameras made by Bourquien of Paris, of the bellows construction, and fitted with Ross's 4-inch landscape lenses, and two smaller cameras made by Horne, and fitted with their lenses, but in place of which I subsequently employed a pair of Ross's 3-inch lenses, with which I had previously worked. The stock of glass plates was, I think 700, of three different sizes, fitted into grooved boxes, each of which contained about twenty-four plates; the boxes of glass were again packed in chests so as to insure their security. Several chests of chemicals, a small still with stove, three or four printing frames, gutta-percha baths and dishes, and a few carpenters tools,

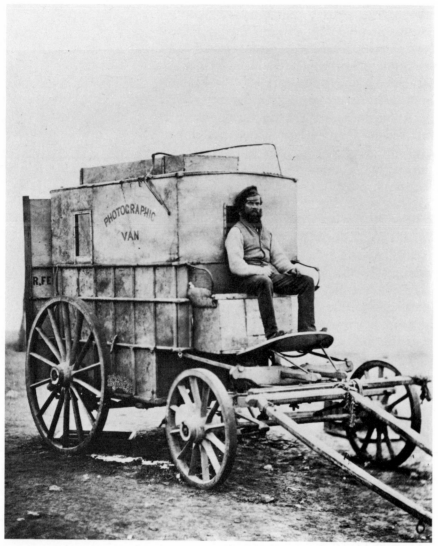

Left: The Artist's Van. Fenton's photograph of his photographic van with Marcus Sparling on the box, taken, we are told, just before the descent into the 'Valley of the Shadow of Death'. Sparling believed that there was every chance that both van and driver might not return from this perilous trip and demanded of his employer that his 'likeness' and that of his carriage be made beforehand.

Above: The engraving of the van and the report as carried by the *Illustrated London News*.

formed the principal part of the photographic baggage.

I must not forget, however, what was to be the foundation of all my labours, the travelling dark-room. The carriage, which has already had an existence chequered with many adventures by field and flood, began its career, so far as its present historian knows, in the service of a wine merchant at Canterbury.

When it entered into the service of Art, a fresh top was made for it, so as to convert it into a dark-room; panes of yellow glass, with shutters, were fixed in the sides; a bed was constructed for it, which folded up into a very small space under the bench at the upper end; round the top were cisterns for distilled and for ordinary water, and a shelf for books. On the sides were places for fixing the gutta-percha baths, glass-dippers, knives, forks and spoons. The kettles and cups hung from the roof. On the floor, under the trough for receiving waste water, was a frame with holes in which were fixed the heavier bottles. This frame had at night to be lifted up and placed on the working bench with the cameras, to make

room for the bed, the furniture of which was, during the day, contained in the box under the driving seat. In the beginning of the autumn of last year, having hired in York a strong horse (but one as we afterwards discovered, of neglected education and of very irregular habits, which were displayed to the greatest extent, in very strong relief, by my assistant, Mr Sparling, who then made his first essay as a charioteer), we set forth on the road to Rievaulx Abbey in search of the picturesque.

From the experience obtained on this journey which was a very amusing, and not unsuccessful one, several modifications were made in the construction of the carriage, and it finally assumed the shape in which it appears in the photograph taken of it on the day on which it travelled down to the ravine called the 'Valley of the Shadow of Death': a picture due to the precaution of the driver on that day, who suggested that as there was a possibility of a stop being put in the said valley to the further travels of both the vehicle and its driver, it would be showing a proper consideration for both to take a likeness of them before starting.

In addition to the purely photographic preparations, were several boxes of preserved meat, wine and biscuits, harness for three horses, a tent, one of Price's candle-stoves, a few tools, and a great many other smaller matters, likely to be useful, the whole being packed up in thirty-six large chests, which took up so much space on Blackwell pier as to make me think with rueful forebodings of the sort of resting place they were likely to find on the shore at Balaklava.

The vessel in which, by the kindness of the Duke of Newcastle and of Sir Morton Peto, my passage was provided, staying two days at Gibraltar, I took the opportunity of buying three horses at San Roque, where were collected a great number both of horses and mules, for the purpose of sale to the British Government.

Photographers, horses, and baggage, all arrived in due time safely at the entrance to the harbour of Balaklava, and after waiting for half a day outside in obedience to a signal saying there was no room, the captain of the vessel got impatient, and the focus of his telescope happening to become deranged about the same time, he could no longer read the signal and so steamed into the harbour, and through much bad language at last got elbowed into a berth near the head of the harbour. Before this was accomplished, however, I went on shore, landing on a real stone jetty, and without getting knee-deep in mud, though on either side of the newly made rough stone road there was plenty of evidence of what a filthy swamp the street must have been.

Strolling through the place to reconoitre [sic], I found plenty to look at. The emptying of Noah's Ark could scarcely have been a stranger sight. Navvies and Croats were working together on a railway, loading waggons, emptying ballast, exchanging 'bono Johnnies' and evidently the best of friends. Leaving the town we passed or were met by a constant stream of costumes on foot, or mounted on every variety of quadruped. Zouaves were loitering about with baggy breeches, Turks with baggier. Making some inquiries of a soldier of the 17th Light Dragoons near Kadikou, there came past some troop horses led or mounted: 'There',

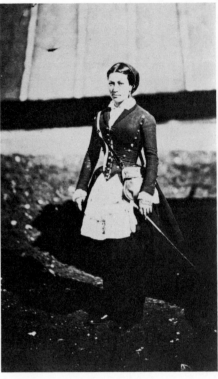

Cantiniere.

said he, 'is our regiment.' I counted them, thirteen in all. 'You don't mean to say that these are all?' 'All that we can mount' he replied. These horses were a sad spectacle: rough, lanky, their heads down, their tails worn to the stump, most of them showing patches of bare skin, they seemed too far gone to be able to recover.

Soon came by a drove of mules ridden or led by Turks, Arabs, Maltese, and Blackies, and conducted by a Highland lad half drunk, mounted on a mule, with toes stuck out and mouth reaching from ear to ear. He grinned out in passing, 'Here's the Royal Highland Brigade.' Having delivered a few letters of introduction and obtained from Mr Beattie, engineer to the railway, permission to place my horses for a time in the railway stables, I returned to the ship, weary with excitement and with the anxiety I felt as to how, in the midst of the chaos and confusion of Balaklava, I was to find any quiet spot in which to commence operations.

Looking back to these scenes, afterwards so familiar as to excite no attention, I feel pleasure in remembering the oddness of the first sight of them, and hope that the Society will excuse me on this account for dwelling so long on what is not information about photography.

That same night, pacing the deck, indulging in a quiet cigar, and calming down our excitement by the influence of the solemn starlight and the still water, the harbour so silent that it was difficult to realise that fact that 150 vessels and thousands of men were crowded into that narrow space, we newcomers were startled by repeated flashes of red light over the hills towards Sebastopol and the heavy boom of artillery. As it went on at the rate of seventy shots per minute, nothing could persuade some of the party that it was not the grand attack, which we heard was just about to be made, and it was with difficulty they were dissuaded from setting off instantly, night though it was, to be present at the grand finale.

Having got the horses ashore, the next thing was to disembark the van, an operation which at first seemed to be as impossible as that of squaring the circle. There were at that time but two spots where anything bulky could be put on shore, – a stone jetty of rough construction, called the cattle-pier, and a stage laid to the shore from the ship *Mohawk*, from which the railway waggons were being discharged. To get at these a considerable part of the harbour would have to be traversed, but first of all it was necessary to obtain the use of a boat large enough to contain the vehicle, and next to get the boat when obtained alongside our vessel. After hunting about for two days, from the admiral to the captain of the port and the captain's secretary, and being sent by them with notes to the captains of Her Majesty's vessels in the harbour, receiving from every one kind attention and promises of assistance, but finding always that either the promised barge was loading with shell and would not be empty for two days, or that unluckily, somebody else had just taken it without orders, or that the barge was there, but the men that belonged to it had just been ordered elsewhere. I saw that if I could get none but official assistance, Sebastopol would be taken probably *vi et*

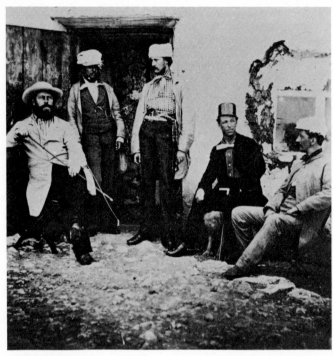

Railway Officials.

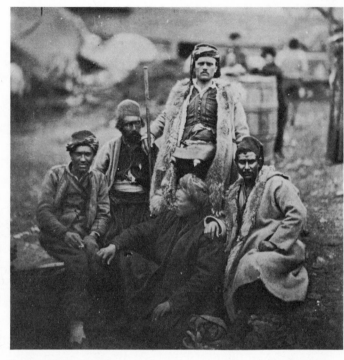

Group of Croat Chiefs.

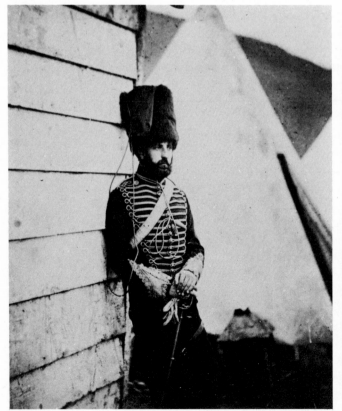

Captain Darnes.

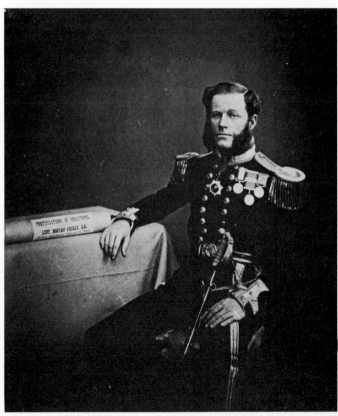

Lieutenant O'Reilly RN.

armis but not by photography. In this dilemma, the master of the transport *Mohawk* came to my aid. He had offered previously the use of his ship's launch, but it was too small to contain the waggon. However, as there seemed no choice but either to fail, or to run the risk of its upsetting in the harbour, I accepted the offer. As the vessels in the harbour were packed side by side like herrings in a barrel, there was no possibility of getting the boat alongside. It was taken to the head of the vessel, and the van being slung over into it, the wheels resting on its edges, it began its dangerous voyage.

Safely landed at last, after many hair-breadth escapes, it obtained a temporary resting place on the part of the shore where the railway establishment was being formed, and in order to avoid wasting time answering questions, my assistant began work by painting the title 'photographic van' on its exterior. A day or two afterwards, while developing one of my first negatives, a conversation went on outside, which I give as a specimen of many similar ones. 'Eh, Jem; what is that?' 'PHO, pho-to-graph.'–'Is that anything to do with "the line"?'–'No; they say there's a chap in their taking pictures.' 'Is there?–then he shall take mine.' There came a knock at the door and without waiting for an answer a pull to open it.

The door being locked, there was another knock and another speech. 'Here, you fellow, open the door and take my picture!' The door was opened to inform the visitor that his wish could not be gratified. 'What did you come for if you're not going to take pictures?' 'Come, I'll have mine done, cost what it may. What's to pay?'–'It can't be done, my man, pay or no pay.' 'Can't it, though! I'll go to Mr Beattie and get an order for it.'

I took a few pictures in this spot in order to enjoy the pleasure of making a beginning, though there was yet much to do before it would be possible to commence in earnest. It was necessary first to obtain some place in which to stow the numerous boxes of material which were lying in the ship's hold. For this purpose nothing less than a hut would suffice, and to obtain one it was requisite to be provided with an order from head-quarters, and so I determined to ride up there and present a letter of introduction, with which, by the kindness of His Royal Highness Prince Albert, I had been furnished, to the Commander-in-Chief. But here an unexpected difficulty occurred. I had neglected to provide myself with saddle and bridle, thinking that so many horses had perished there must be saddles in plenty at Balaklava. It was a mistake: everybody was in want of either a horse or a saddle and bridle, and my horses had not been twenty-four hours in their stable before I received for them an offer of more than twice their cost. The scarcity of horses procured at last the loan of what was needed. One of the railway-officers lent me a saddle, with one girth and a bridle, on condition of a mount on one of my horses. On the third horse, a nautical friend shipped himself, making a sailor's blanket do the duty of a saddle, and rigging up an extempore bridle. Half a mile out of town, in scrambling up a rocky ascent, my one girth broke and saddle and rider went rolling down the hillside

receiving serious damage in the descent. Proceeding on to the cavalry camp, I was fortunate enough to meet with a good Samaritan, Quarter-Master of the 4th Light Dragoons, who lent me a good English saddle, and so enabled me to go on to head-quarters and apply for the wooden hut. After making the application, and finding that no answer could be returned that day, I rode on to the camp, though in considerable pain, in order to get a glimpse of the town, and to find out the quarters of General Barnard, to whom I had letters. He was sitting in his tent with a delightful prospect of lunch on the table, at which he bade us be seated – no unwilling guests.

As I was very anxious to become as soon as possible acquainted with the scenes which the camera was afterwards to depict, he kindly rode with us to some of the principal points from which the best views of the town were to be obtained, and afterwards invited me to come up at once to his quarters, and take a bed in one of his tents, an offer which it was perhaps fortunate that I could not accept, since two days afterwards the bed was smashed by a round shot from the Russian batteries.

The General was going that afternoon with Sir R. England to the monastery, a distance of about six miles, and I did not like, when invited to be of the party, to lose the opportunity of seeing a spot so beautifully secluded, and so interesting from its classical site: though my aching ribs turned into a painful pleasure what otherwise would have been a most delightful gallop over a fresh, breezy upland, intersected with sudden ravines, each with its little streamlet, and variegated with patches of brushwood and ridges of crumbling rock.

The next two days I was unable to move for pain, and had plenty of enforced leisure to think over all the precautions to ensure success that might have been adopted before leaving home.

When well enough to mount on horseback, I went up again to head-quarters, and obtained the order for a wooden hut: on presenting which at Balaklava to the proper official, I was told that the huts were all on board ship, but that if I would come again in about a week, there would probably be some on shore by that time. A week's, perhaps a fortnight's sun-light to be wasted! It was impossible to be satisfied with such an answer. I found at last that there were two huts on shore, appropriated, but not taken away from the store, and, after much trouble, got possession of one of them, and then went to Col. Harding, the command-ant of Balaklava, to ask for a site on which to erect it – a request which was instantly granted.

It took some trouble and time to transport this hut, plank by plank from the other side of the harbour to its destination. The gang of Croats which Col. Harding had kindly furnished me with to level the ground, made themselves scarce the first time my back was turned, and never afterwards appeared, except, doubtless, on pay-day, to receive their three shillings a-day. When the hut was up, and the heavy boxes trans-ported safely to it, I was able to set to work seriously, and occupied myself for some time in taking views in Balaklava and its neighbourhood, and in the cavalry camp beyond Kadikou.

During the period till the beginning of spring, the light and temperature were everything a photographer could desire. Without paying special attention to the condition of the nitrate bath, I was able to take, with the Ross 3-inch double lens, with a diaphragm of about an inch and a half, almost instantaneous pictures. With the single lens, a Ross 4-inch, with an inch stop, from 10 to 20 seconds were sufficient. Towards the end of April, 3 seconds were frequently enough for the proper exposure of negatives with the single lens; in some cases that was too much.

It is, however, with our present facilities, impossible to estimate the relative photographic value of solar light at different seasons and in different countries, otherwise than approximately. I am inclined to believe that the difference is much greater between the actinic power of light at different seasons in the same country, than it is in different countries at the same season. I have taken pictures in England in the spring, with a single lens, more rapidly than at any time in the Crimea. As the weather became hotter and spring began to change into summer, the difficulty of getting successful pictures became in every way greater. First, the actinic power of the light was less with the same collodion, and with the bath in apparently the same condition as in the spring, the time of exposure became gradually longer. As it got hotter still, it became very difficult to keep the nitrate bath in good working order. The consumption of nitrate of silver in making fresh baths was at this time very considerable.

As every photographer knows, a nitrate bath must be allowed to rest for some hours after any change has been made in its nature by the addition of either acid or alkali. These additions must also be so cautiously made, and with so many experiments, to see if the right point has been reached, that where time is an object, it is much better to make a new bath at once, and this we were generally obliged to do, and so the stock of nitrate fell short. This was one of the difficulties which I had foreseen no more than the trouble which the want of a saddle would occasion. It was more easily got over, for on application to the head of the medical corps, I was supplied with a sufficient quantity of fused nitrate of silver to go on with. It was difficult too, in the great heats, to clean the glass plate properly; perhaps I should rather say, that when the heat was intense, impurities upon the glass, which in a lower temperature would have been of no detriment, became centres of chemical action and caused spots or streaks in the negative picture.

It was necessary in the hot weather to thin the collodion to a much greater extent than is usual in England; and even with this precaution it was hard to spread a film of collodion evenly over a large plate, the upper part of the plate drying before the excess of liquid had run off at the lower end of the plate. From the same cause the development of the pictures was more difficult, as the film often became nearly dry in the short time necessary to take the slide containing it to the camera and back again, and then of course the developing fluid would not, when poured on to the plate, run at once all over it without stoppage. Some idea of the heat may

be formed from the fact, that the door of the van being one day in the beginning of June left open, and the sun shining into it, a gutta-percha funnel, which was exposed to its rays, became blistered all over as if it had been laid upon the heated bars of a fireplace. I need not speak of the physical exhaustion which I experienced in working in my van at this period. Though it was painted a light colour externally, it grew so hot towards noon as to burn the hand when touched. As soon as the door was closed to commence the preparation of a plate, perspiration started from every pore; and the sense of relief was great when it was possible to open the door and breathe even the hot air outside.

I should not forget to state that it was at this time that the plague of flies commenced. Before preparing a plate, the first thing to be done was to battle with them for possession of the place; the necessary buffeting with handkerchiefs and towels having taken place, and the intruders being expelled, the moment the last one was out, the door had to be rapidly closed for fear of a fresh invasion and then some time to be allowed for the dust thus raised to settle before coating a plate.

Eventually, I was obliged in the month of June, to cease working after 10 o'clock in the morning. Without reference to the fatigue which would have resulted from work during the heat of the day, it would have been impossible, so far as portraits are concerned, to take any satisfactory ones after that hour, for the glare was so great from the sky and burnt-up ground, that no-one could keep his eyes more than half open.

On one occasion at this time, and only on one, an appointment was made with me for an hour which was earlier than I liked. I had requested General Pelissier to allow me to take his likeness, and told him at the same time that the earlier he could come the better. He promised to come the next morning at half-past four and kept his appointment pretty punctually.

There was little lost at this time by ceasing to take views except such as consisted principally of foreground; for the distant hills, which during the spring were always distinctly marked, and which shone in the greatest variety of rich and lovely colour, gradually merged in the hot weather into one leaden mass, mixed up confusedly with the seething vapoury sky.

Whatever is to be done by photography in these climates must be done either before the beginning of June or after the middle of September, both on account of the physical difficulties which the artist will have to encounter in the heat of the summer, and also by reason of the inferiority of the pictures which nature presents to him at that season of the year.

This difference between the beauty of atmospheric effects at different seasons is very remarkably illustrated in skirting the coast of the Mediterranean or sailing among the islands of the Aegean, where the objects that meet the eye, being all at a considerable distance, are at one season clear and distinct in outline, with richest colour; while in the heat of summer the details are all drowned in one dull misty mass, the extreme distances are invisible, and the glorious colours are shrouded

in a uniform neutral coat of grey.

I am forgetting, however, that my van is all this time at Balaklava, while I am rambling into the Mediterranean. I am afraid it must be left there for the present, for I have already occupied too much of your time. I must pass over the efforts which were made to break in my Spanish horses to running in harness, and how the attempts failed; and how I moved up to the front with six artillery horses, and pitched my tent at head-quarters, but finding it too small to hold all my family and stores, gave it up to Mr Sparling, and had myself to be indebted for food and shelter to the hospitality of friends,–now living in luxury and abundance, and now in want; occasionally sleeping in the general's marquee and sometimes on the bare ground.

At the end of May, feeling my health somewhat impaired, I obtained leave to join the Kertch expedition, but returned to the camp in time to witness the attack on the Mamelon by the French, and the Quarries by our own troops. On the day of the battle,–having taken the portrait of General Pelissier, as already mentioned, at a very early hour, and the group of the three commanders-in-chief in council,–I was spending the afternoon with a brother-in-law and some friends in the 88th with one of whom I had been intimate for several years. I was sitting in his tent with five officers of the regiment, being about to dine together, when Captain Layard brought orders for the formation of a column for the assault on the Redan, my brother-in-law being named as second-in-command of the storming party of 100 men, and our host as commander of the reserve. I shall never forget the sudden hush with which our previous mirth was quelled, nor the serious look which went round the group of brave men receiving that message, which as they knew was to some of them the summons to another world. I accompanied them till they reached the trenches.

There was a fine young man whose face is before me now, as then, when I saw him for the first and last time. He had begged to be allowed to join the storming party in the place of another officer and his request had been, as I think, improperly granted. There was something inexpressibly painful to me in looking at the excitement and pleasure which his expression betrayed.

Having returned to a spot whence the principal attack could be seen, I remained there for several hours, not knowing how time passed, and, like the rest of the group, scarcely conscious of the shot and shell which were hissing over our heads, except on one occasion, when a spent ball, which everybody saw coming, passed through the thickest of the throng, killing one man, who got confused in his effort to avoid it. After everything seemed over and the rattle of musketry grew faint, I went back to the camp, and entering my brother-in-law's tent, found him lying with a grape-shot hole in his arm. While sitting with him, to give him drink from time to time, I could hear in the next tent the moans of the commander of the storming party, who had been shot through the abdomen, till about midnight, when their cessation told that his sufferings were over. From time to time a wounded soldier coming up told

us how things were going on in the Quarries. We could learn nothing of our friends, except that it was thought that some of them were wounded. At last up came the report that one was killed, then another, and another, and as fresh stragglers arrived, the rumour changed into certainty.

The handsome lad on whom I had looked with such interest was missing, but was said to be lying close to the Redan. With a heavy heart I rode back to my own quarters in the grey of the morning, meeting with litters on which were borne silently men with pale waxen faces and ghastly wounds. That afternoon I followed to the grave the bodies of three of the five who had been met to spend the previous evening in social enjoyment.

A day or two afterwards, when dining with General Bosquet, and expressing to him the depression that these events had caused in my mind, I was much struck by his reply. 'Ah,' said he, 'no-one but a soldier can know the misery of war: I have passed six and twenty years of my life burying my most intimate friends.'

I had hoped to add to the collection of views which I had formed, photographs of the scenes since so ably depicted by Mr Robertson, and with that view made everything ready for going into Sebastopol after the attack of the 18th of June, which we all knew to be impending, and which everybody had settled was to succeed so surely, that those who had doubts scarcely ventured to express them. When that attempt failed, and to the list of friends already sacrificed were added new names, I felt quite unequal to farther exertion, and gladly embraced the first opportunity of coming away.

Having lived for the previous month at headquarters which were in a very unhealthy condition, I had imbibed the poison of that outbreak of cholera to which Lord Raglan, General Estcourt, and so many others at head-quarters at that time fell victims, and which the depression consequent upon the loss of the 18th rendered them unable to resist. Providently I was able to get on board ship and outside the harbour before the disease came on. Recovering from that, and beginning to regain strength, a fever brought on by over-work and nervous excitement, made me very glad to find myself at home lying silent and dreaming in the midst of dear familiar faces. So happily ended my photographic experience in the Crimea, with the renewed conviction that 'there is no place like home'.

Just as in the photography Fenton had left out the unpleasant detail, so too did he omit it from his narrative to the members of the Photographic Society. He told his publisher and his wife in his letters just how squalid the conditions were—with the harbour water stagnant and rotting—a breeding ground for disease on account of the hundreds of sheep carcases and other waste which had been dumped into it from the ships. He understated the dangers he was in and omitted to tell his learned colleagues that his van became a favourite target for the Russian gunners. The white van was visible for miles and often mistaken for an ammunitions wagon and shelled. Several letters to Agnew and his wife tell of near misses.

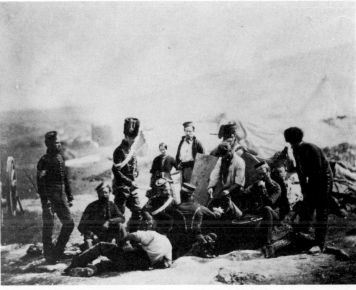

However, he did return with over three hundred unique records of the War. Many of them do not warrant mention—they are merely records of the place—vast expanses of open land with low lines of defences in the middle distance. The portraits and especially the groups make this set of pictures so valuable. Titles come to mind easily—*Cookhouse of the 8th Hussars*, *Council of War*, *Croats* and many other group studies all exhibit Roger Fenton's singular skill in composition. A number of the views are also exceptional. The famous *Valley of the Shadow of Death*—which was not, as often suggested, the scene of the Charge of the Light Brigade, is a peculiarly evocative study. The scarred and battered valley strewn with thousands of cannon-balls is the sum of all the horror of the Crimea.

Cook House of the 8th Hussars.

Group of Clergy.

Alongside Fenton in the Crimea were Russell, *The Times* correspondent, and Simpson, an artist for the *Illustrated London News*. Fenton often mentioned his surprise that Simpson's work was accepted, for it apparently bore little relation to the actual scene and style of the war, but he did include fine portraits of Russell and Simpson in his mammoth series of pictures.

Fenton arrived home in July and was summoned to Osborne House early in August to show the results of his labours to Queen Victoria and Prince Albert. On 8 August 1855 the Queen wrote in her private journal '…We dined alone and looked at some most interesting photos taken by Mr Fenton, in the Crimea,—portraits and views, extremely well done—one, most interesting of poor Lord Raglan, Pelissier and Omar Pascha, sitting together, on the morning on which the Quarries were taken.'

When the Queen and Prince Consort paid a state visit to France later that month they took the pictures with them. Napoleon was greatly impressed and, at his command, Fenton and Agnew took the entire collection to France in September and were received in audience by the French monarch.

In October the pictures were exhibited at the Water Colour Society's rooms in Pall Mall and at many regional centres. The Manchester Photographic Society's Annual Exhibition for 1856 devoted an entire room to

Simpson, War Artist. Many of Simpson's drawings of scenes in the Crimea found their way into the pages of the *Illustrated London News*, often preceding Fenton's photographs of similar subjects by several months.

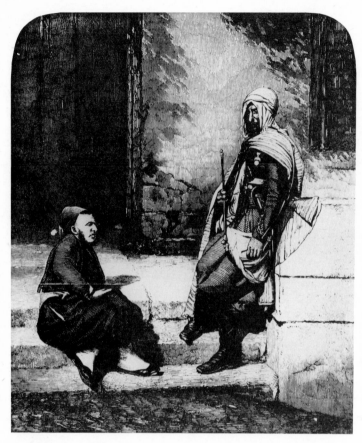

the display of about thirty selected pictures from the series. While the full set of 360 had been taken to France, only 312 found their way on to the walls of the Pall Mall exhibition hall. The exhibition at the Water Colour Society was well received and led to the use of many of the pictures, in the form of engravings, in the *Illustrated London News* in the last weeks of 1855 and the early months of 1856.

Right: General Bosquet–from the exhibition of photographic pictures taken in the Crimea by Roger Fenton.

Left: Spahi and Zouave–an engraving from the *Illustrated London News*, drawn from Fenton's photograph of the same name.

The photographs appeared at many exhibitions in the weeks that followed, and the first were published by Agnew and offered for sale to the public in November. Further parts of the set were published at intervals over the next four or five months until, in all, 337 were available. These could either be purchased singly at between half a guinea and a guinea a print, or in volumes of selected pictures. The 'Complete Work' as sold by Agnew consisted only of 160 prints and was offered for sale at sixty guineas. Four volumes were also published, bound in lavish red leather-cloth covers priced at between six guineas and twenty guineas. These were titled *Incidents of Camp Life* (at twenty guineas), *The Panorama of the plateau before Sebastopol*, a panorama made up of eleven pictures costing six guineas, *Historic Portrait Gallery* at ten guineas and *Views of the Camp, scenery etc* costing a further twenty guineas. Thus 155 prints could be purchased for a total fifty-six guineas or 160 for sixty guineas.

Agnew's investment cannot have been small and it certainly did not produce the returns expected. By the end of August 1856 it was clear both to Fenton and Agnew that their venture had misfired. Sales had been very

L'Entente Cordial.

slow indeed and Agnew had considerable stocks of prints left, despite his advertisements stating that only a limited number of copies could be made from each negative before they broke up. That attempt to make the public buy quickly was a total failure and he contacted the London auctioneers, Southgate and Barrett of Fleet Street, with a view to disposing of the remainder. In all they prepared to auction a large collection which comprised:

> '6 complete sets of the ENTIRE WORK consisting of 160 photographs, in parts as published at £63.
>
> 24 Scenery, views of the camp etc, the series of 50 photographs, in parts, published at £21.
>
> 15 copies of Incidents of Camp Life, the series of 60 photographs, in parts, as published at £21.
>
> 25 copies of the Historical Portrait Gallery, the series of 30 photographs, in parts, as published at £10.10s.
>
> 16 copies of the Panorama qf the Plateau before Sebastopol, in 11 photographs published at 6 gns.
>
> A large number of photographs of portraits Scenes and Views connected with the War. The whole of the original Glass Negatives taken by Mr Fenton in the Crimea.'

The catalogue was published on 22 November 1856 and the sale commenced on 15 December and lasted four days. As well as Fenton's material,

Title page of one of the Crimean albums as published by Thomas Agnew.

all Simpson's unsold drawings were also auctioned.

One day of that sale was devoted exclusively to attempts to sell the remaining two thousand or so copies of Simpson's *Seat of the War in the East* while the other days were shared between Fenton and Robertson, whose unsold stocks were also brought under the hammer. However, Agnew never did recoup his total outlay on the expedition and although the photographs give us a unique insight into the war, and provide us with superb examples of Roger Fenton's work, the venture constituted perhaps the first commercial failure of photography in Britain. But long before the hammer started to fall in the Fleet Street auction rooms, Fenton had forgotten his months in the Crimea and returned to work on his many other projects.*

*It is not an unreasonable assumption that the prices reached at the auction were considerably less than Agnew's original retail prices. Interest in these photographs was very poor as the war came to an end and almost totally died as the peace treaty was signed. For over a century the pictures were regarded as no more than curios. One important library which has assisted with the research into Fenton's work for this book purchased one of Agnew's volumes entitled *Photographs of the Seat of the War in the Crimea* (one of a number of composite volumes produced in 1856 in an effort to improve the poor financial return on the expedition) for sixteen pounds as recently as 1956. Today, however, with the sudden and enormous increase in interest in Victorian photography, the picture has changed completely. As I write this account, news from one of the major auction rooms tells of a volume containing forty five prints (thirteen fewer than the previously mentioned set) attaining a price of 4000 guineas.

Chapter 6
The Photo-Galvanographic Company

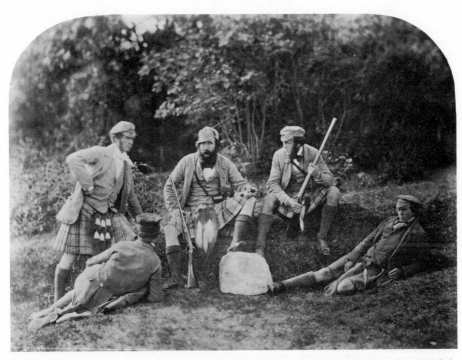

Ghillies, Balmoral.

THE PRINTING of the Crimean photographs and his work for the British Museum kept Fenton busy during the winter of 1855–56 and through the spring of 1856. It was not until the summer of that year that he set off again, with a new photographic van to replace that which had been abandoned in the Crimea, and journeyed north to the Scottish Highlands. He travelled through Dunkeld and Braemar, after a short photographic sojourn in Edinburgh, and produced some fine landscapes. His views of the Hermitage Bridge and the river Braan were well received wherever they were shown – especially at their first exhibition in December at the Scottish Photographic Society.

But 1856 saw Fenton turning his attention to a completely new pursuit – that of producing photographs for the patent Photo-Galvanographic Company. The company had been formed to produce, by a patent process, photo-engravings for sale to the general public, and was founded by Paul Pretsch, a print-maker from Vienna and one time manager of the Imperial printing works in that city. He had arrived in Britain in 1854 and had, in the November of that year, patented the process he had invented in Vienna. British Patent 2373 was issued to him on 9 November 1854.

The idea that Pretsch patented was not unique. Many others had evolved methods of engraving from photographs and, in fact, one such method patented by Fox Talbot would ultimately cause Pretsch a great deal of inconvenience. However, Pretsch's system achieved one thing that no others had previously managed – the inclusion of half-tones – the greys which make the photographic image unique. At the time, the half-tone dot screen had not yet been invented and all engravings from photographs – such as those used in the *Illustrated London News* from Fenton's Crimea portraits, were hand-drawn impressions of the original photograph. Even the more advanced process which Pretsch was now attempting to market

did not completely dispose of the need for long and careful hand-retouching on the part of the engraver and it took an average of six weeks hard work to prepare just one plate. After all that work, only about five hundred prints could be made before the image started to break up. As with all such processes, the first prints were of a far superior quality to the last – so a sliding scale of charges was evolved, the price depending on the state of the plate at the time the print was made.

The process itself was the subject of two patents – the August 1854 patent already mentioned and a series of improvements suggested in a second specification dated August 1855.* The process was an interesting one and consisted of first preparing three solutions: glue in water (later Pretsch specified gelatine instead of glue), silver nitrate and potassium iodide. The glue could be replaced by collodion if required. A small amount of the glue was added to each of the other two solutions, the remainder of the glue being kept warm, and mixed with a strong solution of potassium bichromate ('bichromate of Potass', as Pretsch called it). The nitrate solution and the iodide solutions were then both added to the bichromated glue and strained to remove lumps and impurities in the solution. Like the collodion process, this mixture was then poured on to a glass plate and the glass was tilted in every direction to ensure an even coating of the solution. The plate was allowed to dry. A print, perhaps rendered translucent by waxing or greasing was then put into contact with the plate and exposed to light for a substantial length of time. (As with the collodion process, the sensitivity of the emulsions were greatly reduced by drying but, of course, in the case of these plates it would have been quite impossible to use them wet. So, as a result, the low sensitivity had to be accepted and the exposures increased accordingly.)

The development of the print was, in its earliest days, simply by washing under running water. Later a solution of either borax or sodium bicarbonate was used. The image started to appear in relief, after a short time in the washing water, as the gelatine or glue swelled up. The areas of the plate which had been exposed to light (an exposure of many hours) were hardened by that light whereas the unexposed areas were still soft. Under the influence of the water, they swelled up to form the image. The plate was then washed in 'spirit of wine' (acetic acid?) and, after the moisture had been wiped off, coated with a mixture of varnish and turpentine. It was then allowed to partially dry before the surplus varnish was removed with a further application of turpentine. The plate was then washed again and allowed to dry. The next step was a coating of gutta-percha (used extensively at the time for making funnels, dishes and other chemical vessels). Gutta-percha is a resinous substance not unlike rubber which formed an intaglio mould which could be removed when dry. The gutta-percha mould was a perfect reverse replica of the glass plate. This was then coated with graphite which, under the action of electrolysis, was replaced by copper to produce a very thin copper plate. The copper plate, when removed, was a replica of the original plate with raised detail. The plate was then reinforced with a lead backing and inked up to make the prints.†

Retouchers were called in to hand engrave over the plate and accentuate

*It is interesting to note that the first patent is entitled 'Improvements in producing copper and other plates for printing'. This seems to have been the standard form of patent titling. Many first patents for a particular process were titled 'Improvements in...' although there was no previous specification of the process before the said 'improvements'.

†Pretsch also listed other ways of making the prints – including a system of inking up the original glass plate and transferring the image to a litho stone.

fine detail which the process had lost. Thus a print produced by the process in its original form was a curious mixture of the camera image and the artist's pen. In one or two prints, the artist did so much after-work to the plate that the viewer could be forgiven for not noticing that it was from a photographic original.

Pretsch was no photographer, however, and he left it to others to provide the pictures for his patent process. Roger Fenton took up his appointment, as manager of the Photographic Department and chief photographer, in August 1856, almost two years after Pretsch filed his original patents. By that time, however, the company had extensive premises in Islington and a staff of processors and engravers ready for work.

Fenton did not waste much time in producing some results. The first publication from the company was part one of *Photographic Art Treasures*, subtitled *Nature and Art illustrated by Art and Nature* which was scheduled to be a long-running series of photo-galvanographic engravings from photographs, sketches, paintings, etc., produced by contemporary workers.

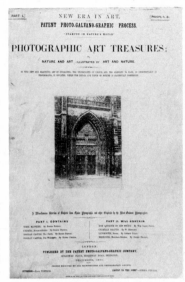

The title page of the first part of *Photographic Art Treasures*.

In the short time Fenton had been employed at Holloway Place, the company's head office in Holloway Road, he had not had time to acquire prints by other photographers and so that first publication of four prints was entirely his own work. The prints, *York Minster from Lendall, The Cedars, Monmouthshire, Raglan Castle, the Porch,* and *Raglan Castle, the Watergate,* were printed by October 1856 but did not go on sale to the public until December. They were warmly received, but sales were slow. The prints were issued in three qualities – 'choice proofs', 'proofs' and 'prints' with prices varied accordingly. The dearest, the choice proofs, cost ten shillings and six pence with the other two qualities at seven shillings

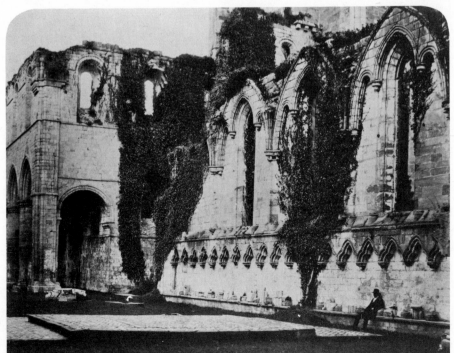

Fountains Abbey.

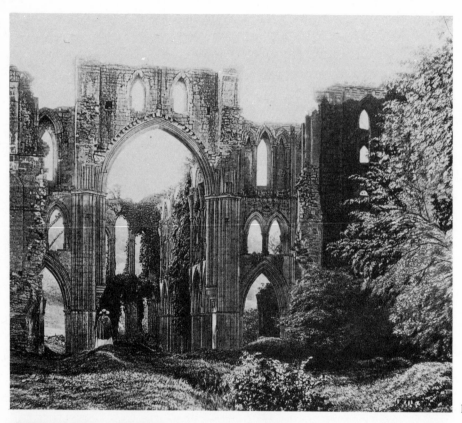

Rievaulx Abbey, the Transepts.

Beehives, Burnham Beeches. This picture, and
the view of the Cedars in Monmouthshire are
two of the most heavily retouched prints from
Fenton's photographs published by Pretsch.
It was this feature which was so frequently
criticised by Sutton in his magazine.

York Minster from Lendall. Published in October 1856.

Cedars, Monmouthshire.

and six pence and five shillings respectively. So the prices were high which probably accounted for the slowness of sales.

In the December 1856 issue of the magazine *Photographic Notes* an advertisement appeared for the company heralding the publication of the first part of *Photographic Art Treasures* and announcing that the second set of four prints would be available in the New Year. Part two was to contain *Don Quixote* by Lake Price, *The Cradle* and two pictures by Fenton entitled *Hampton Court* and *Fountains Abbey*. When it did finally appear, only two of the advertised pictures were in the series. *The Cradle* and *Fountains Abbey* were replaced by *Crimean Braves* by William Howlett and *Lynmouth, Devon,* by Lebbin Colls.

Part three was scheduled for publication in February 1857 but did not appear until March. Three of the prints were by Fenton, thus proving that he was having greater difficulty than anticipated in persuading other photographers to contribute their works to the collections. This quartet comprised Fenton's *Beehives, Burnham Beeches, Rievaulx Abbey Choir* and a curiously Victorian composition entitled

'*Hush lightly tread. Still tranquilly she sleeps,*
She watches suspending even my breath in fear
To break the heavenly spell, Move Silently.

This was a study of a small girl sleeping, and was about as well received as the fourth print, from a painting by a Mrs Carpenter entitled *No Walk Today*.

Photographic News, edited by Thomas Sutton, reviewed each set as it was published, and had little praise for the efforts of Fenton and Pretsch. The main criticism was the use of the retoucher's pen which detracted from the appearance of the finished print. However, by April 1857, the month after part three was published, the manager of the company, in a letter to *Photographic News*, confirmed that the process was now sufficiently advanced to dispense with hand retouching on the plate.

Subsequent parts of the series *Photographic Art Treasures* were scheduled to contain photographs by Fenton, Rejlander, Lake Price,

Lebbin Colls and others but there are no surviving prints from these later sets.

The company planned ambitious projects and many of these were listed on the title page of the first volume of *Photographic Art Treasures*. They included a photographic essay by Fenton on Bolton Abbey in Yorkshire and it is assumed that this was to make use of photographs he had taken on a previous trip. It is assumed that this was actually published – publicity material from the company leads the writer to that conclusion although extensive research has failed to bring any of the prints to light. The full title was *Bolton Abbey and the Admired and Picturesque scenery in its vicinity, photographed from nature by Roger Fenton*, and the pre-publicity announced that the series would be published in 1857, in cloth covers at five guineas for choice proofs, three guineas for proofs and two guineas for prints.

Fifty Choice Stereoscopic Pictures Taken by Roger Fenton during a summer tour in 1856, Great Remains of Old Abbeys existing in the nineteenth century with picturesque Nooks and Corners in their Vicinity and *The Cathedral Antiquities of the British Empire* also appeared in the lists of future projects. Other pictures by Fenton were advertised in part three as being 'in preparation' and one print, a hand-coloured picture entitled *Bedtime, a family Group* and described as 'suitable for the Palace or the Cottage' was published at seven shillings and six pence for a monochrome proof, three shillings and six pence for a monochrome print and seven shillings for a coloured print. Only the print quality was available tinted. The pictures in preparation included the view of Fountains Abbey which had originally been scheduled for the January *Art Treasures*, together with further views of Rievaulx, and of Fountains and such titles as *Redbrook on the Wye*, *Girlish Meditation, Art and Arms* (a series of Crimean portraits) and *Courting, signing and sealing*, another image in the same vein as *Hush, lightly tread*.

A series of prints were actually made from Fenton's 1856 Scottish views but were never published. Paul Pretsch lectured to the Birmingham Photographic Society on the subject of his process in September 1858 and used as examples of his work Fenton's *Bed of the Garrawat* and several of the Dunkeld and Braemar pictures.

In the closing weeks of 1857, the company communicated to the photographic press its intention to wind up its affairs. Sutton, writing his editorial in *Photographic Notes* was not surprised. He launched into a harsh attack on the work produced, criticising the choice of photographs as being totally unsuited to the process, and in particular, expressing misbelief that a subject such as *Beehives, Burnham Beeches* could ever have appealed enough to Fenton for him to have photographed it. Of the third part of *Photographic Art Treasures*, Sutton had a good word only for the view of *Reivaulx Abbey* claiming that the remainder would be better forgotten!

However, the company does not appear to have closed down quickly, for Pretsch, at the Birmingham meeting, certainly gave the impression that it was still a thriving concern. Sales were low, however, and as there is no further review of any of the company's publications after the third set of

Photographic Art Treasures it is difficult to imagine how they managed to continue. Several photographic historians make the assertion that the Bolton Abbey series was published, and assume that the fifty stereoscopic prints were also put on sale. If that was the case then a certain income from those would help the company to continue. This writer, however, cannot either prove or disprove those claims, despite strenuous efforts to do so. However, Pretsch soon joined De la Rue as a lithographer and Fenton continued with his other work. His appointment, like the British Museum contract had not been full-time anyway.

Pretsch's process had been the subject of legal struggles with Fox Talbot who claimed his Photolyphic engraving patents covered Pretsch's invention too. Many companies, and at least one major magazine of the period, bowed down to Talbot's pressures until, eventually, and as with every other attempt by Talbot to control photography in Britain, a test case at last defined the scope of his patents and the limits of the restrictions he could place.

Pretsch's process was quickly superceded by superior processes but it remains a vital link in the development of photo-engraving. Typical of Fenton's ability to be at the forefront of most of the developments in photography at the time, his association with Pretsch had formed perhaps the first commercial venture of its kind.

Chapter 7
Landscape and Architecture

Salisbury Cathedral, the East End.

WHEN ONE CONSIDERS the type of photography to which Fenton turned when the art was only a hobby to him, it is perhaps not incorrect to suggest that many of the jobs to which he turned his attention commercially were merely undertaken in order to provide the capital to enable him to work in the fields of landscape and architecture.

His first set of exhibited prints, at the 1852 Exhibition at the Society of Arts, consisted of thirty-nine compositions without a single still life or portrait amongst them. There were five views of Tewkesbury including three of the abbey; twelve views of Cheltenham; eight taken in and around London and four taken in Gloucester. The remainder of the set was made up of three Russian views from the expedition to Kiev and Moscow, one view of his birthplace at Crimble and a series of views of Tintern Abbey.

At exhibitions in the following years, more landscapes and architectural pictures appeared and it was not until he was commissioned to photograph the Royal Family that portraits first appeared in his panels of work.

In 1854–55, while testing the photographic van in Yorkshire, it had been architectural photographs which were produced: Bolton Abbey, York, Mount Grace Priory in Cleveland, the majestic abbeys of Fountains and Rievaulx, these had been the subjects for his camera. Using the waxed paper negative and the old calotype printing paper, or the 'new wet plate' and the calotype paper print, Fenton became one of the masters of British landscape and architectural photography. When he returned from the Crimea it was to this aspect of photography that he immediately turned. The British Museum continued to supply the basic income while Fenton

At Rievaulx, Yorkshire.

devoted the remainder of 1856 to the production of his superb series of views of the Scottish Highlands and some of the finest photographs of the Yorkshire Abbeys ever taken. He returned to York and almost copied *York Minster from Lendall*–which had been one of the most beautiful of the views printed from the earlier visit. He rephotographed and extended his series of views of Fountains and Rievaulx, using many of them, together with the Bolton Abbey series, in connection with his work for Pretsch.

Tintern Abbey had been photographed in the waxed paper days and that, too, came in for a second attempt by him. Between the end of 1857 and the end of the following year he produced literally hundreds of superb architectural photographs of sites all over England and Wales, together with some of his finest landscapes. Raglan Castle yielded up a number of superb studies; the Cheddar gorge, the River Wye, Furness Abbey (which seems to have held a curious fascination for the photographer who returned to the site on several occasions throughout his career), the Lake District and many other places.

In the summer of 1858 he paid an extended visit to North Wales, producing some fine studies of the meanderings of the River Conway. Deep gorges, wide pools, rugged Welsh hillsides proved perfect subjects. Later that summer he travelled further north into Lancashire to the estates on which he had been brought up, using one of the family homes as a base while he travelled around photographing as he went.

One of the finest sets of photographs produced at that time was the large and beautiful series of studies he made in and around Stonyhurst College,

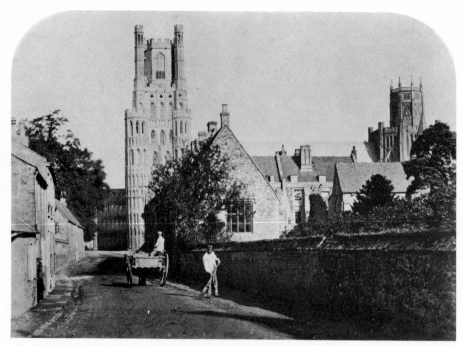

Ely Cathedral.

Salisbury Cathedral, the Lady Chapel.

Wells Cathedral, the nave from the west end. An ambitious interior taken probably between 1858 and 1860 showing Fenton's superb control of lighting–already successfully demonstrated by the Stonyhurst interiors.

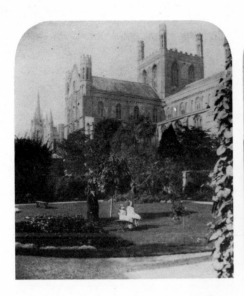
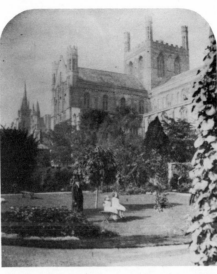
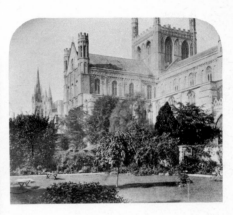

Peterborough Cathedral.

a large Catholic Public School near Blackburn. The buildings of the college may have been the initial inspiration but they certainly were not the only subjects he found.*

As well as providing a chance to see a large number of examples of his work which, as far as can be ascertained, cannot be seen in other collections, the Stonyhurst prints give us a chance to accurately date many of Fenton's pictures. Fenton kindly supplied both signatures and dates on many of the pictures dating them at 1858 and 1859.

He appears to have arrived in Lancashire in late summer or early autumn of 1858, judging by the sunlight and shadows in the pictures. He had two or perhaps three large format cameras (and a stereoscopic camera), as the pictures fall into three rough size groupings. That he used at least two cameras is certain – one of the Stonyhurst pictures in the RPS Permanent Collection shows Mr Fenton, and a second camera, outside one of the college buildings.

The three sizes are approximately 13×17 inches, 12×12 inches and 9×11 inches, allowing for a variation of plus or minus half an inch in each of these measurements. However, the knowledge, from the British Museum letters, that he was using a 15×15 inch camera a year before he came to Stonyhurst could suggest that the two smaller sizes might be from that size of plate with very harsh cropping.

That he did crop his pictures at least to some extent is virtually ascertained by the fact that the British Museum pictures fall into roughly rectangular formats. The use of a fixed lens-panel camera, as must surely have been the case, would contribute to the chances of ultimately being able to produce a horizontal rectangular print of architectural subjects without the annoyance of converging verticals. Without rising front, severe cropping of the bottom of a square negative is the obvious answer to that problem and is perhaps the only way the camera could be kept level without losing at least some of the picture.

Although the lens panel on his cameras may well have been fixed, there is

*It was, in fact, the rediscovery of the set of pictures which Roger Fenton had presented to the school which started this writer on the task of researching his life. These pictures, many of which were new to students of Fenton's photography, had lain for years, unrecognised, in the school. They constitute one of the major collections of his work in this country and demand a more detailed report perhaps than some of his better known photographs.

Windermere.

ample proof that simple movements at least were appearing on cameras as early as 1857. In particular, swing back movements were certainly in use by the spring of 1858 when Fenton himself wrote of his experiments with various new lenses designed by Petzval, Ross, Shepherd and others. In his writings he notes:

> The third picture I took contains objects presenting very different planes. It has a church in the distance with a house down the lane. When I first tried it, only one portion of the picture was in focus–the more distant parts being quite out of focus. I then altered the parallelism of the ground glass and advanced the side of the picture upon which the image of the church fell about half an inch. In this case the focus came pretty sharply upon a line starting at the corner of the church and going down, its sharpness commencing at this point and going through the railings, which formed the termination of the picture on the right; at the same time there is considerable depth, so much that these houses are in tolerable focus. At the same time you will notice that the lines are much straighter than you will get them with an ordinary landscape lens giving a picture of the same size. The picture was taken with an aperture of $\frac{7}{8}$ths of an inch. The focal length is 20 inches.

Shadbolt, in reply to Fenton's observations at the meeting of the Photographic Society on 2 March 1858 made it quite clear that such movements were already fully accepted and understood by photographers:

> Now the arrangement he made, of putting the ground glass a little aslant, that is to say, making use of the swinging back of the camera, was simply another arrangement for taking a plane surface.

Returning to the pictures, however, it certainly does appear to be the case

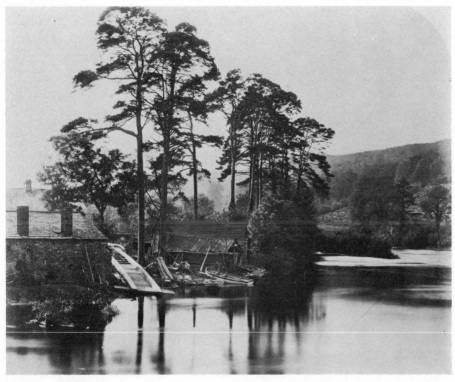

View from Newby Bridge, Windermere.

that the square prints are of subjects where the photographer had total control over the positioning and height of the camera. In pictures like the view of Hardwick, where he could get the camera up on to an opposite balcony, *A vista at Furness Abbey*, and to a certain extent, the superb *Terrace and Park at Harewood House*, he has used the foreground to good advantage, combining the ability to achieve architectural accuracy with a desire to use as much of the available negative area as possible.

Fenton was such a perfectionist that architectural accuracy must surely have been always in the forefront of his mind. It is not impossible, therefore, that the greater proportion of his negatives were shot on square or almost square plates. Only in two prints have I seen the accuracy of the record sacrificed in the cause of convenience – in two views of the Sodality Chapel at Stonyhurst and the University Museum at Oxford where, in both cases, the space in which the photographer could work was restricted. Rather than lose a part of the subject by keeping the camera level, converging verticals were the lesser of two evils. It is probable that both these pictures, as seen in his prints, represent the image on the negative almost in its entirety.

It is noticeable too that many of his finest landscape pictures are square or near-square in format. In the Stonyhurst collection of pictures, almost without exception the smaller landscapes are square, or within an inch of being square. In these pictures perhaps more than any others, the artist in Fenton has come to the surface. This writer makes no excuse for reproducing a large number of these compositions in this book. The quality evident in them makes their inclusion compulsory.

The views of the River Hodder and the Ribble, with their superb

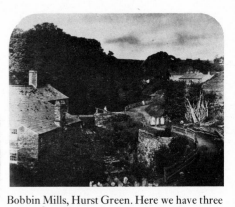

Bobbin Mills, Hurst Green. Here we have three versions of the same photograph. The large format view (*top,* 17 in × 13 in approx) appears, by the position of the shadows, to have been the first of the three to be photographed. The second, the stereoscopic pair uses the same people as the first but in slightly changed positions. Very shortly after taking the stereo pair, Fenton must have made the third view on his smaller camera (11 in × 9 in approx) using different figures in place of the little girls in white visible on the first two photographs.

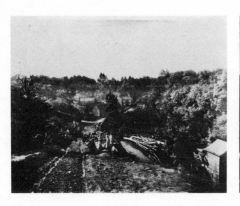

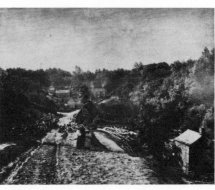

Here again we have two versions of the same view and once more the only differences are the altered groupings and the reduced negative size. Here there does not appear to be much of a time difference between the two exposures as there is no great change in the shadows.

perspective and perfect balance, enhance Fenton's already established reputation. The series entitled *The Keepers Rest, Ribbleside,* using the high steep banks of the river to offset the small but powerful group at the water's edge, perfectly conveys the relationship between man and his imposing environment.

If there ever was any doubt as to the artistic genius of the photographer, that must surely be dispelled by the superb composition entitled *The Pavilion in the Garden, Stonyhurst* with its strong symmetrical pattern of lines converging in the centre of the print at the small ornate gazebo. Perhaps this picture was not well received when first exhibited, for many of his other similarly angular and linear compositions were severely criticised. However, today, it must surely be recognised as his finest picture. The Stonyhurst collection had three prints of this superb picture but, sadly, all are a little faded at the centre detracting somewhat from the overall appearance. Considering the methods by which many Victorian photographs have been stored in the past century, we can be thankful that their condition is no worse.

The Avenue in the Garden, Stonyhurst. One of Fenton's powerful compositions using perspective to the full.

Also photographed at the same time were a number of views of Hurst Green village–the little road known as the Dene and the Bobbin Mills alongside it. The reasons behind the proliferation of photographs of the mills can be explained quite simply by the fact that the Fenton family owned extensive lands and property in the immediate vicinity of the village. The local inn, known as the Fenton Arms (and now the Punch Bowl) was owned by John and James Fenton (Roger's father and uncle) as were the manors of Dutton, Bayley and Ribchester, the houses of Grindlestone and Clough Bank and the Mills themselves. In the local rates list for 13 September 1858 the mill is listed as being owned by John Fenton and tenanted to Richard and Thomas Holden. Bayley Hall might well have been the house in which the photographer stayed while taking these pictures.

It is obvious from the photographs that Fenton was not always content with his first attempts at each composition. Many of the photographs, taken on the largest size plate appear to have been taken in the early morning–and then rephotographed later in the day on the smaller camera with the groups of figures rearranged. It is not surprising that he might with to make a second attempt at a particular study but it is curious that all these second attempts should be made from exactly the same viewpoint but with the smaller negative size. (That the smaller prints are the second attempts is assumed as the compositions and groupings in all these prints are very much better than their larger counterparts.)

At the Sale Wheel on the Ribble, near the confluence of the Ribble and the Hodder, Fenton produced an extensive series of prints of local fishermen at work, carefully posing each angler against the spectacular scenery. This series must surely be recognised as being on an equal level of significance and historical importance as Hill and Adamson's Newhaven collection. One particular image stands out from an altogether impressive series. That is a picture of a solitary angler at the edge of the near-still water overshadowed by the steep banks. The reflections and the attitude

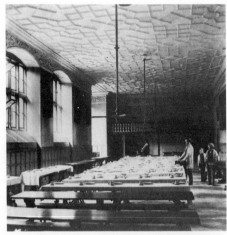

Once again, the repeated shot on stereo. In both cases, both large format and stereo repeat pictures were taken with the refectory full of boys having a meal–suggesting that these two pictures might have been taken as test shots for the more ambitious pictures which followed them.

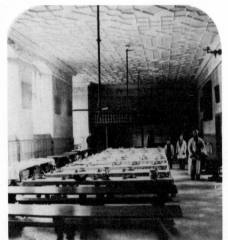 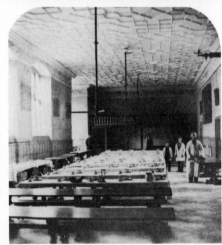

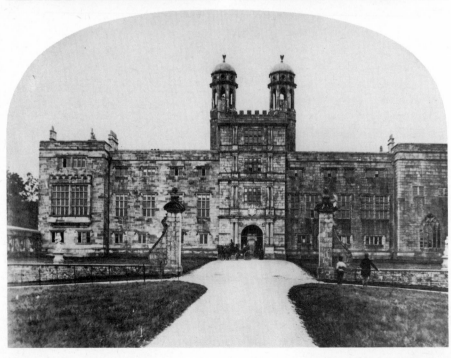

Stonyhurst College.

of the fisherman contribute to an overall impression of peace, and a perfect balance of man and nature.

Just how long Fenton remained in Hurst Green is not known—but his stay must have been quite considerable. In addition to the pictures already mentioned he photographed the college buildings extensively, producing both exterior and interior views of a very high quality. As well as the interior views of the Sodality Chapel there are imposing views of the exterior of the main college buildings and the nearby church. The school is fronted by two large ponds which produced some splendid pictures with the tall renaissance architecture reflected in the water, behind a small group of boys and Jesuit masters launching a punt.

One of the most important of the school pictures is one entitled *The Refectory, Stonyhurst*. There are two such titles, one having been known for a number of years and often used to describe Roger Fenton's masterly control of lighting. That view, of the inside of the refectory hall with a small group of servants and boys lit by strong and powerful shafts of light through the tall windows has long been recognised as a masterpiece. The second picture to bear that name is one of the nineteen or so unique pictures in the school's collection and shows the refectory full of boys having a meal. The same strong lighting and deep shadows are evident suggesting perhaps that the first view of the almost empty hall was a test exposure for the second.

Fenton returned to the college in the winter of the following year, 1859, to present to the school a leather-bound folio of his work and a special display easel. The original gift was of at least 126 signed views with several prints of each. At that second visit he took at least three pictures—one entitled *Christmas Day 1859* showing the boys skating on the now frozen pond. The only prints of this delightful picture that I have seen are at Stonyhurst. The other two known products of the visit are *Hoar Frost, Stonyhurst* (in both the RPS and the Stonyhurst Collection) and *The Terrace at Stonyhurst* (RPS Collection).

The College was most appreciative of this large gift and immediately framed a large number of the views: 'In one room there are forty-five large photographic views of the building and its environs taken and presented by R. Fenton Esq. Amongst them are views of the college, its adjoining grounds and choice places along the borders of the Hodder.' So wrote the *Preston Chronicle* in 1870 in a booklet entitled *Stonyhurst Past and Present*. It is a pity that the college did appreciate its gift so much for, of those forty-five pictures, and twenty-two others out of the set of 126, no trace remains.*

Fenton obviously had to rely on the co-operation of many people when he was at work—permission was needed to work on people's land, to photograph their buildings. Help and a great deal of patience was required of all the people who figure in his pictures. To them all he was generous, providing prints from his photographs to all who had helped him. Many of the local farms and cottages have one or two faded albumen prints of local views with that now valuable signature along the bottom in splendid copper-plate handwriting.

*The set is assumed to have consisted of 126 views as the numbering runs from 31 to 126 with many gaps and a number of un-numbered views. Only fifty-nine different views now remain, and are thankfully being carefully preserved against further loss.

Chapter 8
Legal Matters and Stereoscopic Pictures

THE PHOTOGRAPHIC SOCIETY which Fenton had been instrumental in forming had grown rapidly since 1853 and, by 1856, had become so large that there was a real need for a full-time secretary. Fenton, who had held the office since its inception, stepped down. For the following two years he worked actively for the Society on its committees and, in 1858, he was elected Vice Chairman.

In 1857, in view of his vast legal knowledge, he was approached by the Society of Arts and asked to sit on a committee being formed to study the copyright aspect of photography. His work on this committee did not start until 1858 and he made use of the time between accepting the offer of a place, and actually sitting on the committee, by writing the following open letter to his photographic colleagues and inserting it in the Journal of the Photographic Society.

> 2 Albert Terrace,
> Albert Road,
> Regents Park,
> Dec 30, 1857

Sir – The Society of Arts has appointed a Committee for the consideration of the present state of the law of Art-Copyright. Its object is to ascertain precisely the defects of the existing law and to collect and compare the opinions of practical men as to the means of amending it.

If, as is to be hoped, it is able to arrive at some definite conclusion upon the latter part of the subject, it will then endeavour to obtain from Parliament a new Law of Fine Art Copyright.

There are many gentlemen upon the committee who are well acquainted with all the questions that have arisen about the copyright of pictures and statues. Most of these questions have been discussed in the courts of law. Some points, important in their character, are yet unsettled; while upon others, decisions have been given, correctly deduced, no doubt from existing law, but strangely opposed to the dictates of common sense.

With respect to that branch, however, of the Fine Arts to which our Society is devoted, there is no existing law. It has been suggested, and it is just possible, that some clause in present Acts of Parliament may be so comprehensive as to include photographers within the limits of its application; but this possibility is too shadowy to deter any one who is moderately bold and entirely unscrupulous.

To make the rights and duties of photographers, in question of copyright, unmistakedly clear, is not needed; but to provide a simple method of preventing any deviation from the one, and of protecting the other, is very necessary now, and will every day become more so, as photography grows in importance and multiplies the number of its applications.

There will be no dissent from the opinion, that when a photographic artist has obtained – perhaps by much outlay, – certainly by the exercise of taste and skill, the fruit, partly of natural gifts, partly of careful cultivation, – a valuable negative, the artist is entitled to all the benefit

that he can gather from it, and that he has a right to prevent anyone from reaping the harvest who has not sown the seed.

Again, no photographer will claim the right to take a negative for publication of any picture, statue or engraving which belongs to another person, and not to himself or to the public, of which he forms a part. And yet there is nothing, so far as we know, in our present law, to debar him from encroaching upon the rights of others in the latter case, nor in the former to protect him in the undisturbed possession of what is his own.

We may be pretty sure, from the well-known energy of the Society of Arts and from the intimate knowledge of the subject possessed by many of the members of the committee just appointed, that there will soon be a new law of Fine Art Copyright. Therefore I write you this letter, asking you to insert it in the Society's Journal, in order that Members of the Society, and your readers in general, may give the subject their careful consideration.

As I have undertaken to act upon the Society of Art's Committee, and am therefore responsible to my brother photographers for a proper attention to their interests, I venture to ask their assistance in the task.

This may be given in the shape of accurate statements of the facts of any cases of injury sustained or committed by photographers through the absence of any copyright-laws relating to them.

In such statements, the names of persons concerned should, where not matters of public notoriety, be left in blank.

I would ask also their suggestions as to the best means of protecting the copyright of their works; the extent of protection that ought to be given, and the nature of the penalty that should be attached to any violation of the artist's right of property.

If this request be responded to, the information and the opinions gathered together might then be examined and sifted by the Society at one of its monthly meetings, and thus a result be obtained, which, if not final, will at any rate express the wants and views of the photographic world at the present time.

ROGER FENTON

The whole issue really revolved around the controversy as to whether or not photography was an art form. One well-known artist of the period is said to have dismissed the claim that it was by stating that it relied wholly for its success on chemistry and a camera. Fenton is reported to have replied that a similar approach to painting—which was dependant on pencils, paint and canvas, would therefore dismiss that as an art form also.

Eventually, after four years of meetings, campaigning and legal work, the Fine Arts Bill was passed through Parliament securing, once and for all, copyright on all original photographs. It should be remembered that the Fine Arts Bill would have been presented to Parliament with photography excluded had it not been for the tireless efforts of Fenton and his fellows in the Photographic Society, and the cause of photographic copyright might have been put back several years as a result.

Roger Fenton's interest in stereoscopic photography dates back almost to his first interest in the subject as a whole. We know, for certain, that he took a stereoscopic camera with him when he went to Kiev and Moscow in 1852–and several examples of his work still survive in the Science Museum Collection. However, as we have already mentioned in this work, his real successes in stereoscopy were not achieved with the large format stereoscopic pictures (as required by Wheatstone's Reflecting Stereoscope) but with the smaller versions which soon became a common sight in almost every Victorian Drawing Room. Stereoscopy was the first of the Victorian photographic 'crazes'–to be followed by the 'carte-de-visite', the small commercial portrait costing only a few pence which heralded the explosion of photographic popularity and commercialisation preceding Fenton's retirement from the profession.

His first known work for Lovell Reeve, the Covent Garden publishers in Henrietta Street (the same street in which Frederick Scott Archer had his studio) was published in 1859. Reeve had the ambitious and revolutionary idea of publishing a magazine devoted to stereoscopy and illustrating it with original photographs. This was the first, and to date the only magazine, devoted entirely to that particular branch of photography. Fenton was one of its first contributors and, through the years of its publication, one of its most prolific and admired. The magazine, at half a crown per issue, was not cheap, but as original photographs were used– hand printed and hand-mounted in stereo pairs–the high price is not surprising.

The first issue of the magazine appeared in July 1858 containing three stereo pairs–none of them by Fenton. In fact, although he took many pictures for the magazine in 1858, his first pictures appeared in Number XI in May 1859 when a picture of Ely Cathedral was used as the second of that month's three illustrations.

The Gernsheims, in their book on Roger Fenton in the Crimea attributed to him a book entitled *Stereoscopic Views of North Wales* containing twenty-one pairs of stereo pictures with a text written by Fenton. This writer, after extensive research has been unable to trace such a book– although there is substantial proof that Reeve published Fenton's stereoscopic essay. The probable answer is that Reeve published Fenton's pictures as a boxed set of stereo cards for use in the home stereoscope–a practice he repeated with many other successful series of pictures both by Fenton and by other photographers. There is certainly no mention of a book of that name in any of Reeve's catalogues which have come to this writer's notice.

It is also highly unlikely that, had such a book been published, Fenton would have provided the illustrations–some twenty in number, for the book *The Conway in the Stereoscope* which was written by J. B. Davidson and published by Lovell Reeve two years later. Fenton took the North Wales pictures in the summer of 1858 so it is conceivable that such a boxed set of stereo views could have been published before the end of the year. With Fenton's heavy commitments in 1858 (as witnessed by his mammoth output of work) he would have had little time to write a commentary to his

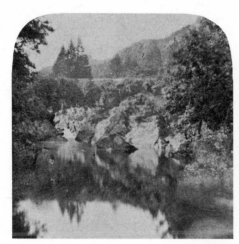 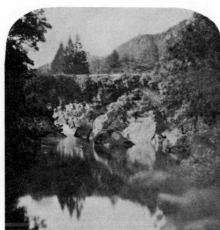

All three illustrations are from *The Conway in the Stereoscope* written by J. B. Davidson and published by Lovell Reeve.

Pont-y-Pair.

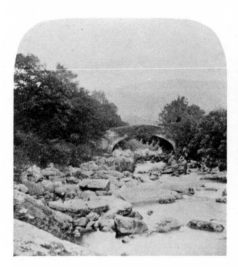 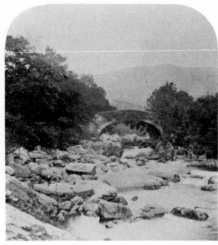

Pont-y-Lledr.

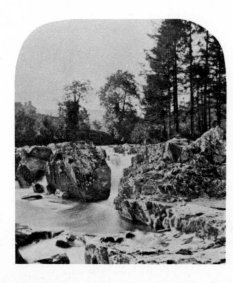 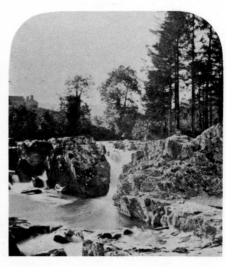

Falls of the Llugwy.

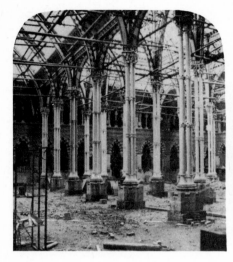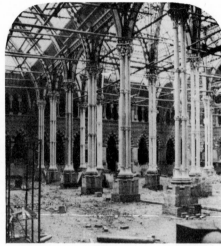

Interior of the New Museum, Oxford.

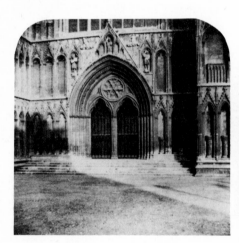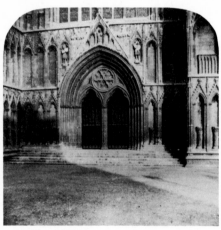

York Minster, the West Door.

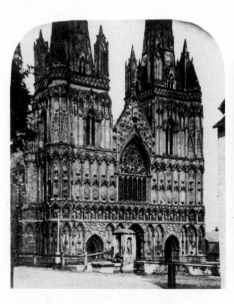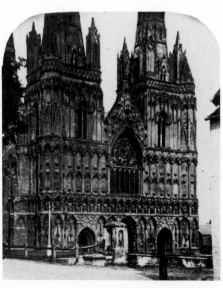

Lichfield Cathedral.

pictures as well. Even if he had had the time, it is unlikely that such a specialised market could have carried two such similar books within two years of each other.

However, Fenton's work for Reeve was by no means slight. The month after his initial picture was published, one of the North Wales stereoscopes was published in the magazine–a view of Pont-y-Pant. July 1859 saw the publication of three views of the Temple Collection of Antiquities– stereoscopic views of subjects photographed in the large format for the British Museum. The Megatherium at the British Museum figured in the August edition as did another of Fenton's Cathedral views–this time of Peterborough. From then until February 1860, the British Museum stereoscopes formed his total contribution to the magazine, with one or two per month finding their way on to the pages, enhancing even further the financial reward from an already highly lucrative assignment.

Although only the museum pictures were appearing in the magazine, Fenton's stereoscopic pictures of other subjects were not being ignored. Towards the end of 1859 Reeve published the stereo views of the Stonyhurst visit as a boxed set of fifteen cards entitled *Stonyhurst and its Environs* and priced at one guinea.

March 1860 saw the publication of a superb stereoscopic picture of the interior of the Oxford Museum under construction. The commentary to the photograph read:

> The accompanying stereograph taken by Mr Fenton during the past summer represents the interior of the Museum in the course of erection at Oxford. Great interest attaches to this building in consequence of its being one of the most remarkable instances in modern times of the revival of True Gothic Architecture. 'Although I doubt not' says Mr Ruskin 'that lovelier and juster expressions of the Gothic principle will be ultimately arrived at by us than any which are possible in the Oxford Museum, its builders will never lose their claim to our chief gratitude as the first guides in the right direction; and the building itself–the first exponent of the recorded truth–will only be the more venerated the more it is excelled.'

It was not until August 1860 that Reeve started to publish selected views from the set of Stonyhurst pictures in the magazine. That month two of the pictures were accompanied by a view of the west door of York Minster to give Fenton all three published pictures to his credit. Reeve had, by that time, added a further publication to his lists–a monthly wallet containing three stereographs, entitled *The Stereographic Cabinet*. This, like the magazine, retailed at half a crown making it, on the face of it, rather poorer value for money than its rival. Fenton's work appeared in almost every issue of the *Cabinet*–starting with the first in 1859 which included his picture of the statue of Thalia in the British Museum.

His work was appreciated greatly by Reeve and, one presumes, by the avid buyers of both the magazine and the *Cabinet*. Many of the accompanying texts were filled with praise for his work. The commentary on the *Interior of the Chapel of the Sodality of Our Lady, Stonyhurst* starts:

We have rarely met with a stereograph of an interior of more beautiful quality than the accompanying one taken by Mr Fenton in the new Chapel of the Sodality of Our Lady, lately erected in connection with the Roman Catholic College of Stonyhurst. Having already given a history of the college when speaking of the Refectory, it only remains to direct attention to . . . the admirable effects of light in the picture . . .

And of the refectory picture, surprisingly, little was said about the photography, although we today look upon both views as being among Fenton's finest pictures and among the best available examples of his skillful control of light.

Of his Ribble pictures, which also found their way into the magazine, Reeve's writers commented:

> . . . One of Mr Fenton's delightfully cool landscapes of river scenery taken on the Ribble in Lancashire. There is much delicacy, it may be observed, in the lights and shadows of the foliage with sufficient gradation of tint to show good aerial perspective and distance. The water, except where it eddies round the point, is placid and transparent, and the whole picture, when nicely printed, has an agreeably soft and luminous aspect.

Certainly his stereographs appear to have met with almost universal acclaim – in contrast to much of the large format material which was often harshly criticised.

So impressed was Davidson by the North Wales pictures that he wrote in the opening lines of *The Conway in the Stereoscope*:

The exact date of this photograph entitled *Spoils of Wood and Stream* is uncertain. It was certainly in the set of photographs presented to Stonyhurst College in 1859. It therefore must have been taken before Christmas 1859 and probably in 1858, making it one of Fenton's earliest still-life compositions.

> In the autumn of last year, the stereographs which form the illustrations of this volume were taken by Mr R. Fenton at the same time, and frequently from the same point of view as those larger pictures which attracted so much attention in the Photographic Society's Exhibition of 1858–59. A series of proofs of these stereographs having come into my possession, I determined, in the course of a visit to North Wales in the spring of this year to follow in Mr Fenton's footsteps and examine for myself the spots he had selected for the subjects of his art. Many of them are places regularly visited by every tourist; others are situations known exclusively to the artist or the angler. But, with few exceptions, all were equally new to me I have endeavoured to collect together what associations of local history lay in my path, and by forming them into a consecutive narrative, I hope that an additional interest may be given to the stereographs In the present instance, the area which has been traversed is somewhat confined, but it is full of legendary interest, and abounds with monuments which excite a stranger's curiosity. Accordingly, the subjects which I have introduced in these pages are closely allied to the route indicated by the illustrations, otherwise a much larger field of investigation might have been embraced. To Mr Fenton's labours, my own have been strictly subsidiary.

James Bridge Davidson Esq MA 1860

The bulk of Fenton's contributions to the *Stereoscopic Magazine* continued to be drawn from the three series of pictures – The British Museum, Stonyhurst, and North Wales. He did include a few more cathedrals and castles – Lichfield Cathedral, York Minster and Raglan Castle together with some views of Oxford appeared during 1860–2.

As we shall shortly see, much of Fenton's later work was concerned with still life of a truly Victorian nature. It was with a stereograph of one such composition, *Fruit and Flowers* that the magazine announced with regret his departure from the world of photography in 1862. The writer did not miss a perfect chance to expound one of his pet theories concerning photography towards the end of his narrative:

In consequence of the eminent photographer Mr Fenton having retired from the profession in which he had embarked with such enthusiasm, we are tempted to give another of his charming compositions of fruit and flowers. It is the last of his productions of this kind that can be offered to our subscribers. Neither fruit nor flowers are good subjects for photography. It has long been deemed hopeless to be able to apply the art to the purposes of botanical illustration. This and one or two

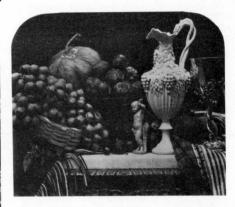

Above: Parian Vase, Grapes and Silver Cup. One of the series of variations on a theme produced in 1860 and 1861. Fenton took dozens of pictures of this type many of which survive in the Royal Photographic Society Collection.

Above Left: Like so much of Fenton's large format material, these compositions, too, were also photographed for the stereoscope. This type of photography was very well received by the *Stereoscopic Magazine*'s subscribers.

Left: The similarity between one view and the next is unmistakable.

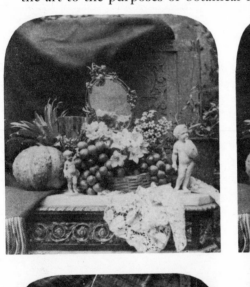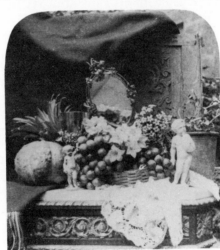

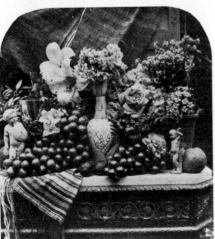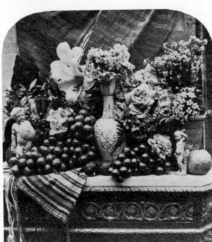

other pictures already given in our magazine are equal to any that have been produced; and it is not likely that any further use will be made of photography for the delineation of such subjects.

However, despite that fact that 'the eminent photographer' had retired from photography, Lovell Reeve continued to publish his work. After the appearance of that last still life in October 1862, a further eighteen examples of his work were published before the magazine vanished from the bookstalls a year later. Even in the last issue, dated October 1863, Reeve found space to publish one of the North Wales stereographs photographed five years earlier.

One of the pictures which appeared in the magazine brought to our notice a most interesting narrative which, for the first time, actually gave some reference to the equipment Fenton used. The picture was *Chinese Curiosities* of which two illustrations by Fenton appeared in the issue for April 1861:

> This is one of the compositions lately exhibited by Mr Fenton on a large scale in the rooms of the Photographic Society. While taking the group with his large lens, he took it also with his camera of six lenses for the stereoscope. The object in the centre is an ivory casket, laid on its side to show the carving on the top, which it will be seen is in high relief.

The 'camera of six lenses' was a strange title to give to a piece of photographic equipment, but the solution to the problems that phrase raised might be found in the following extracts from the Photographic Journal of 22 March 1858:

> MR FENTON:—Sir, I have had the opportunity of taking a series of pictures by Professor Petzval's lens, and I may as well, before showing them, state that there are three double lenses but only two pairs of these are used for taking landscapes, and the other pair is substituted for the back combination arranged for taking landscapes for taking portraits; in no case are there more than four lenses used for taking a single picture, so far as I am at present informed.

The reference to a four-element construction as 'four lenses' leads to the possible conclusion that the 'camera of six lenses' might in fact refer to the complete Petzval set of three pairs. Shadbolt adds further strength to this theory when he addressed the meeting at which the lenses were discussed thus: 'I think it has been proved by Mr Fenton that my objection was a perfectly sound one inasmuch as it was stated that the lens was composed of three pairs, whereas we are now informed that it is composed of only two pairs, one pair being interchanged with another for special purposes.' I think from that comment that we can assume, bearing in mind that the terminology in these early days was rather ambiguous in many cases, that this indeed was the system of 'six lenses' to which the writer in the *Stereoscopic Magazine* referred.

It should perhaps be added at this stage that Fenton would probably have been using a single lens stereoscopic camera at the time. The arrange-

ment of two lenses taking both views for a stereoscopic pair at the same time was not in very widespread use at the time, preference being given to one lens and a moving darkslide–the two pictures being taken in sequence rather than simultaneously. The first binocular cameras were introduced in 1851–J. B. Dancer being a leader in that field. Monocular stereo cameras, however, had been in use since the early days of photography. Thus Fenton's large format stereo pictures taken in Russia on waxed paper negatives would have been taken in sequence, as would his Crimean stereos and the pictures at present under discussion. Like most innovations in photography, the binocular camera was not instantly accepted and single lens stereoscopic cameras were still in production–and new models were still being introduced long after Fenton abandoned photography.

Chapter 9

Fenton finishes with Photography

IN JANUARY 1859 Fenton exhibited a selection of his recent photographs including the products of a return visit to Tintern Abbey. Other subjects included Raglan Castle, views on the Wye, the Cheddar Cliffs and a series of 'tableau' pictures titled *Nubian Water Carrier, Pasha and Bayadere* and *Returning from the Fountain*. Thomas Sutton, in *Photographic News*, reviewed these latest products with somewhat less than total approval. At that same exhibition were a number of views of Tintern taken by Francis Bedford, and Sutton's review of Fenton's material was strongly biased towards the suggestion that Fenton might learn a little from Bedford's skills.

Later that same year Fenton paid a visit to Oxford and produced an outstanding series of pictures–one of the stereoscopic pairs eventually appearing in Lovell Reeve's magazine. He also produced a number of studies entitled *September Clouds* which, together with the last of the British Museum pictures, were all put on exhibition towards the end of the year.

Perhaps the most unusual of Fenton's photographs to date were the three 'tableau' compositions. This was an aspect of his photography which cropped up occasionally. In the photogalvanographic days he had produced *Hush, lightly tread* and *Bedtime*. The Royal family photography in his early professional days had produced the *Seasons* and *Les Petits Savoyards*. Now, in 1859, he once more returned to his painting days and attempted once more to portray, with the camera, the sort of subject better suited to the painter's brush. One can, perhaps, assume that these last essays into this rather sentimental aspect of photography finally got the idea out of his system, for Fenton never again attempted such subjects.

He turned his camera towards stately homes, photographing Harewood House in Yorkshire and producing there perhaps his most impressive pictures. He seems to have been almost obsessed with straight lines and with perspective. The same angular and linear compositions which were tried out at Stonyhurst at last reached near perfection in *The Terrace and Park, Harewood House* which was first exhibited in 1861.

Fenton also visited Haddon Hall, Hardwick Hall and Chatsworth in Derbyshire and paid a return visit to Windsor Castle where he photographed the buildings from almost every possible angle!

At about this time, two writers, William and Mary Howitt were planning the first of two volumes on the *Ruined Abbeys and Castles of Great Britain* for their publishers, A. W. Bennett of Bishopgate in London. The text of the first volume opened with the words:

In this volume the Publisher has availed himself of the accuracy of Photography to present to the reader the precise aspect of the places which, at the same time, are commended to his notice by the pen. It appears to us a decided advantage in the department of topography, thus to unite it to photography. The reader is no longer left to suppose himself at the mercy of the imaginations, the caprices, or the deficiencies of the artists, but to have before him the genuine presentments of the object under consideration. We trust that this idea of our publisher will

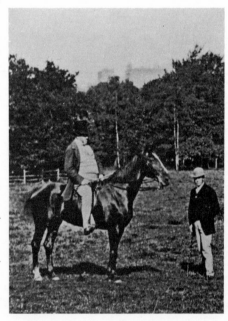

Grandfather Maynard on horseback.

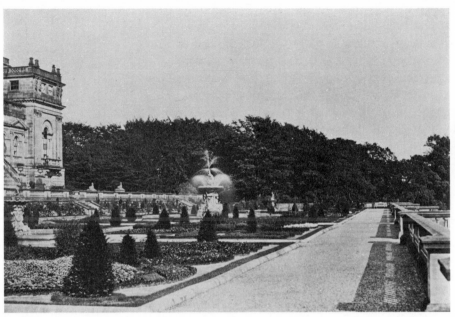

Harewood from across the lake.

The Terrace, Harewood House.

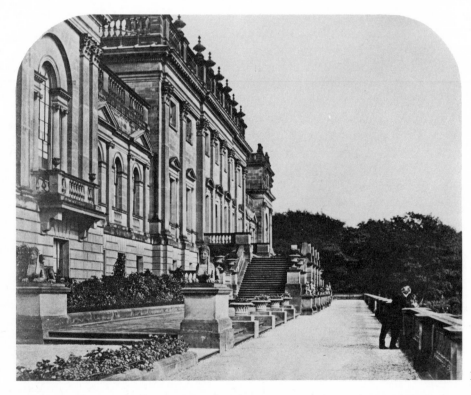

Harewood, the Upper Terrace.

be pursued to the extent to which it is capable; and that hereafter we will have works of topography and travel illustrated by the photographer with all the yet-to-be improvements of the art, so that we shall be able to feel, when reading of new scenes and lands, that we are not amused with pleasant fictions, but presented with realities. With this sentiment we submit the present work to the public, as a step in the right direction, and as an evidence on the part of the publisher of a desire to assist in authenticating literature by the splendid achievements of modern art.

21.st October 1861.

The photographers which the Howitts approached for the illustrations for their new book numbered eight in all: Francis Bedford, George Washington Wilson, W. R. Sedgefield, S. Thomson, T. Ogle, Dr Hemphill and a partnership known as 'McLean and Melhuish' were chosen together with Fenton. It would appear that the illustrations were chosen after the texts were written and the photographers were requested to submit a number of illustrations for final selection.

Fenton is believed to have offered twenty-four of his many superb pictures of the abbeys and castles he had visited during the preceding eleven years, yet only two were ultimately selected. These were two rather poor views of Furness Abbey which appeared in the back pages of the first volume. Having examined both volumes carefully, there is little doubt, on the evidence of the pictures included, that not only were Fenton's the poorest views, but their print quality, likewise, was not all one would expect it to have been. Notable amongst the prints in the books are those by Bedford (renowned for his superb print quality) and Sedgefield. Fenton's prints in the copies of the book that have been examined have faded badly and unevenly, while those produced by Bedford have fared considerably better. Close examination of the prints under a glass shows that the Bedford pictures were both sharper than Fenton's and of a much finer image quality. The only possible answer to this is that Fenton merely printed two of his early views of Furness and offered these to the Howitts. Certainly the quality of these two images is reminiscent of his late calotype or early collodion days where grain size was considerably larger and it could be that a general falling off of interest in photography was already touching him in 1861.

The bulk of the photography in the books was by Sedgefield – he contributed sixteen out of the total fifty-three views, with Fenton providing two and Bedford six.

Fenton's current photography at that time (late 1861), however, was far removed from the architectural views in which the Howitts expressed interest. He was producing endless series of still life compositions, most of which bore the same title – *Fruit and Flowers*. Endless variations on a composition of flowers, grapes and a chalice with assorted other fruit and vegetables earned him enormous respect amongst photographers throughout Britain and Europe and, in 1862, a Medal at the International Exhibition 'for excellence in fruit and flower pieces and good general photography'.

Nowadays we cannot really understand the huge appeal of these

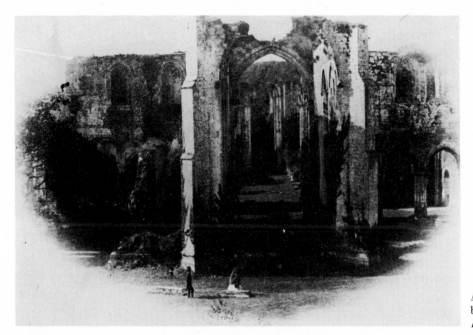

A View of Furness Abbey—from the Howitts' book *Ruined Abbeys and Castles of Great Britain.*

peculiarly Victorian productions, but there is no doubt that, in their day, they perhaps earned for Fenton more respect and appreciation in photographic circles than anything he had previously produced. In fact the very things that were praised in Fenton's day as being his best work are now appreciated less—and, not surprisingly, the reverse also holds. His bold use of straight lines in his landscape work was frowned upon at the time!

Photography had come a long way in the eleven years since Roger Fenton abandoned a thriving legal practise to enter what the Queen had then called the 'black art'. The process had been completely changed—from the paper calotype to the glass collodion plate. Emulsion speeds had increased, the system had become much more flexible and image quality had been improved beyond recognition. But, suddenly, Fenton decided that the moment had come to give it all up and resume the legal work he had equally suddenly abandoned.

Many reasons have been proposed for this sudden decision—amongst them a sadness at the temporary nature of photographs caused by their fading without apparent reason. He had previously confessed to his close friend, Dr Diamond, that he just could not understand how some of his pictures were so quickly affected by the atmosphere and faded round the edges. However, judging by the vast wealth of material we still have today, that can be discounted as an exceptional rather than an habitual occurrence with his work. The quality of the remaining examples of his later work—at Harewood, Haddon, Hardwick and Windsor, together with the superb print quality of the remaining still life prints tends rather to lead us to the conclusion that, although fading was certainly a problem in the earlier days of the British Museum pictures and some of the Stonyhurst views, he knew enough by about 1861 to be able to control more successfully, the fixation and washing of his prints.

Another possibility which has been put forward was his apparent

annoyance at the low esteem in which photography was held by the world as a whole. This is too trivial a reason for so successful a photographer. Fenton made so much money out of the commercialisation of photography that any suggestion that commercialisation sickened him can likewise be discounted. He had certainly not been slow to jump on photography's first commercial bandwagon – the craze for stereoscopic photographs when it swept the country.

What is more likely is that the advent of the next craze – the 'carte-de-visite' also brought with it a noticeable drop in standards and that was too much for him to tolerate. Fenton's photography had never been cheap, his prices always at the top of the scale. With only a few photographers working in the fields of landscape and architecture, he could command high fees for his work. His success depended entirely on his skills and his artist's eye for composition and balance. However, with the advent of the 'carte' – a small portrait picture the size of a visiting card and costing only a few pennies, quality was all too often sacrificed for expediency and profit. Literally thousands of photographic establishments opened up throughout the country and the continent. Speed was the only way to profit. The cost per photograph was so small that a photographer had to work at high speed in order to produce the turnover required to provide a living wage. For a time the public was totally uninterested in the formal studio portrait of the size produced in earlier years. The market for the stereo cards dwindled and the fad of buying prints of well-known places, was replaced by an even greater demand for 'cartes' of well-known people. Not all the studios were bad, of course, and many turned out work of the highest quality. But the competition was greater and the return lower. The London Stereoscopic Company, one of Fenton's rivals in the stereograph market turned its attention to the carte-de-visite and became very successful exponents of the style. The bigger London companies spent their time photographing Royalty and celebrities from the stage, the Church and politics. Very soon these were on sale in almost every town.

The day of the large-format camera, with its patient operator who was satisfied with perhaps only three or four pictures per day, was for a time at least, a thing of the past. Publication of Fenton's decision to quit photography was made in the *Photographic Journal* dated 15 October 1862. In the same issue an advertisement heralded an auction sale of all his materials and equipment to be held in London the following month. That advertisement read:

IMPORTANT SALE OF CAMERAS, LENSES, NEGATIVES AND OTHER APPARATUS OF THE CELEBRATED PHOTOGRAPHER ROGER FENTON

Mr J. C. Stevens has been favoured with instructions to sell by AUCTION at his Great Room, 38 King Street Covent Garden, London, on Tuesday and Wednesday November 11th and 12th at $\frac{1}{2}$ past 12 precisely on each day, the valuable and extensive Photographic Apparatus of Roger Fenton Esq, consisting of his first class cameras and lenses, and other apparatus, made expressly for him by the most

Advertisement from the *Photographic Journal* announcing the sale of Fenton's photographic effects.

eminent English and foreign makers; also many hundred Published and Unpublished negatives &c. On view the day prior and morning of the sale and catalogue had.

In *The Times* of Tuesday 4 November, John Grace Stevens announced another sale in which 'a capital lot of photographic apparatus consisting of cameras and lenses by Ross, Ottewill and other well known makers' and 'photographic views by Roger Fenton' would be auctioned. At first, this seemed a repeat of the *Photographic Journal* advertisement with the dates changed. The advertisement was repeated on Friday 7 November noting the sales as 'this day at Mr Stevens' Great Room'.

The Times also carried a larger and more detailed advertisement on Monday 10 November–a reprint of an advert which had appeared the previous Saturday which read:

> Mr J. C. Stevens has been favoured with instructions to sell by auction at his Great Room 38 King Street Covent Garden, on Tuesday November 11th and two following days at half past 12 precisely on each day, the valuable and extensive photographic apparatus of Mr Roger Fenton; consisting of superb lenses from 6 inches to 1 inch most of which have been made for Mr Fenton by those celebrated opticians Andrew Ross, Jamin, Shepherd, Boutrais and Hermagis, cameras by Ottewill and Bourquis, various useful apparatus consisting of camera stands, gutta percha troughs and baths, glass baths mounted and unmounted, Wedgewood porcelain troughs and several hundred sheets of best plate glass, numerous plate boxes, printing frames made by Bourquis of all sizes, portable dark tent with pony truck built by Holmes of Derby, the well-known photographic carriage by the same builder, lay figures, a skeleton on a stand, splendid silk and satin draperies, Chinese, Turkish and other costumes, rich satin hanging &c; also the valuable negatives of all sizes, consisting of upwards of 1000 of English, Welsh and Scotch scenery and interiors. On view the day prior and morning of the sale and catalogues had.

One can perhaps assume that the 7 November sale, despite the incredible coincidence, was the equipment of another disillusioned photographer together with a private sale of some pictures taken by Fenton but owned by a third party.

In all there were numerous cameras, thirty lenses and hundreds of plates which had never been published. Fenton also had a giant camera which produced a negative three feet square and that too was auctioned. The sale was given a short mention in both the *Photographic Journal* and *Photographic Notes*. The former reported that:

> Mr Fenton's sale was well attended and in general the lots fetched very good prices. The lenses especially sold very well, many wishing no doubt to possess an instrument which had been used by one so generally esteemed as Mr Fenton has been.

As is often the case in reports of exhibitions, sales etc, one wonders if the

two correspondents were at the same sale for, in the *Photographic News*, we read:

> At the recent sale by auction of the photographic effects of Mr Fenton, a singular discrepancy of appreciation was manifested in the valuation of the means and the end.... The negatives in many instances realised very small prices indeed. In some cases three 10 × 8 negatives and a print of each sold for eight or ten shillings. The reason for this was probably the fact that many of the negatives were in bad condition with blistered and cracked varnish. The cameras and other appliances had the neglected dirty appearance of having been long out of use and did not produce high prices. The photographic carriage of which much has been said, was a very convenient but somewhat clumsy and omnibus-like vehicle. We did not hear the price it realised.

Frequent reports at the time, and in subsequent publications may have given the impression that Fenton sold everything at that auction. The references to the 'entire stock of glass plates and prints' certainly gives this appearance. However Fenton certainly kept at least one set of his prints long after he abandoned photography. They were handed down through his family until the 1930s when the set became the basis of the impressive collection of his work now held in the Permanent Collection of the Royal Photographic Society.

So, the plates and the equipment were sold and Roger Fenton was once more a lawyer. The buyers had acquired bargains – getting three plates and a print from each for eight or ten shillings was a bargain indeed when we consider that eight years earlier, that same purchase from Fenton himself had cost the Privy Purse almost four pounds.

There is a certain amount of mystery surrounding Fenton's legal career prior to his photographic days. He had been called to the Bar in the Inner Temple on 9 May 1851 as a fully qualified barrister but, if most accounts are to be believed, practised as a solicitor. However, when he abandoned his photographic business and sold his equipment ('Having made such a resolution, Mr Fenton thinks it wise to deprive himself of all that might be a temptation to him to revert to past occupations') Roger Fenton returned to the Bar as a barrister, with offices at 4 Harcourt Buildings, Temple.

In the *Law Lists* of the day, his name appears under the 'Counsel' section from 1852 onwards with his Regents Park address of 2 Albert Terrace being quoted. All through his photographic career he is still listed as a barrister with no comment to the effect that he is not practising his profession. However, on his return to the Bar the words 'North circ. WR, Manchester and Salford Sess' are added telling us that he was now employed in provincial court circuits and sessions. One can therefore assume that he was rarely to be found at 4 Harcourt Buildings. He appears, from *Law Lists*, to have given up the Temple address in 1865, and carried on his practise until 1869. However, from *Boyle's Guide* there is no mention of his name in the court lists after 1865. It is possible that the omission from *Boyle's Guide* is an error. It is also possible that the *Law Lists* continued to print his name after he retired – his health had never been

good since the Crimea days and ill-health might have curtailed his resumed legal career. That the latter is true is the more probable. If we believe the *Law Lists*—ie that he continued to practise as a barrister in Manchester, then the logical assumption is that he left or sold Albert Terrace. However, as Albert Terrace remained his home for the rest of his life, that theory is obviously ill-founded. This writer prefers to believe that *Boyle's Guide* was correct in its suggestion that he retired in 1865.

When his departure from photography was noted in the *Photographic Journal*, the editor of the journal expressed the hope that although he was no longer involved directly with the practise of photography, he would not become a stranger in the Society's rooms. From the 15 October 1862 issue of the journal we can read:

> To the exertions of Mr Fenton the Photographic Society owes its existence, and for many years it has had the benefit of his counsel and advice; it is therefore with unfeigned regret we make the announcement of his resolution, which is, however, mitigated by the hope that, although he retires from the practical operations of the art, he will still occasionally attend the meetings of the Society, which owes so much to him and where his presence is always so welcome and agreeable.

However, Fenton does not seem to have taken up their kind offer on many occasions. The one recorded occasion when he did pay a visit to the scene of his past successes was in December 1866 when, to loud cheers and applause, he joined the Society's Christmas meeting and was presented with the first silver 'Prince Consort Medal' in recognition of his work in founding the Society.

By the time of that presentation, Fenton had taken up a new position, probably only part-time, as a legal advisor to the Stock Exchange. This practise he probably ran from his home, described at the time as being 'some miles from London'.

His health, never strong, finally brought about his death at the age of forty-nine on 8 August 1869. An obituary in the 15 September edition of the *Photographic Journal* paid tribute to his enormous contribution to the many causes with which he had been associated in his struggle to gain for photography a standing in the art world.

> The subject of our memoir, the late Mr Roger Fenton, was one of the early promoters of the Photographic Society, and for several years after its establishment filled the post of Honorary Secretary. To his energetic exertions was mainly due the great success which attended the Society at the time of its first institution; and up to the period of his withdrawal from photographic pursuits, in October 1862, few members took a more active part in the discussions carried on at its meetings...
> ...Mr Fenton took a lively interest in the creation of the Archer Fund, and acted as joint Treasurer with Sir William Newton. He was one of the Trustees in whose names the amount stands invested for the benefit of the widow and family of the late Mr F. Scott Archer. Upon his retirement from photographic pursuits, Mr Fenton returned to the

profession of the law and became subsequently connected with the Stock Exchange. He died on Sunday evening 8th August after a very short illness in the 50th year of his age.

In the many years since Roger Fenton's death, his name has been kept in the forefront of photographic history mainly on account of the Crimean War photographs. At the beginning of this biography this writer expressed regret at this rather narrow appreciation of Fenton's work but there is no doubt that the widespread interest in Fenton, as a direct result of those three hundred pictures, has helped ensure that the vast wealth of his material we have today has been carefully looked after.

Fenton's importance as a photographer is obvious – the technical and pictorial merits of his work guarantee for him a permanent place among the great names of photography's history. His importance as a pioneer in the organisation of photography must also never be underrated as it was as a direct result of his endeavours that we have the benefits today of the premier photographic society in the world.

Chapter 10

Roger Fenton and Francis Frith

Fenton's decision in 1862 to sell all his equipment and, as far as we know, all but one set of his photographs, was the opening paragraph of a new chapter of the history of his work. We have read earlier that the plates and prints were sold for, in many cases, ridiculously low prices. Just how low those prices were in proportion to the value of the material can be appreciated from the following account of their subsequent fate.

There is little doubt that a number of the buyers present at that sale were private individuals who were there with a view to acquiring, for personal or sentimental reasons, a memento of the great man's work. However, the commercial print publishers must also have been there. It is certain that one at least, Francis Frith, was either present in person or at least represented at the auction.

Francis Frith, once an apprentice to a Sheffield cutlery manufacturer and subsequently to a grocer in Liverpool had turned to publishing and writing while still a relatively young man. He turned to photography as a means of illustrating his writings and is best remembered, photographically, for his photographs taken in Syria, Nubia and Egypt, including the very famous series of views of Abu Simbel. His commercial acumen helped him to make considerable profits out of his photography and he very soon had a nation-wide distribution set-up geared to the task of bringing his work to the notice of people in every corner of the country. To move full time into publishing and distribution was a logical progression for him and this necessitated the removal of his business from Liverpool to new custom-built premises in Reigate.

Francis Frith and Co; soon became *the* publishing house to which all the leading photographers of the period turned for the marketing of their work. Listed among those whose work passed through Frith's hands were George Washington Wilson and Fenton's great rival, Francis Bedford. Fenton, however, does not appear to have used Frith for his work. Frith's business was only really established in the Reigate premises at the latter end of Fenton's active photographic career—in 1859 or 1860 and Fenton continued to market some of his material himself and pass the remainder through Colnaghi's of London. Fenton, by that time, was not producing a very great quantity of marketable material in large format—using the larger size usually for personal or exhibition purposes and marketing his stereo material through Lovell Reeve.

Just how much of Fenton's work Frith purchased at Stevens' auction rooms is uncertain, but there is good reason to believe that he acquired a fair proportion of the material offered for sale. At some time subsequently there appeared a series of folios entitled *The Works of Roger Fenton* published by Frith. Exactly how these were prepared, or when they were published is yet another of the apparently unanswerable mysteries of Fenton's career. There are several options open to us—the first of which is that these were merely published by Frith, during Fenton's lifetime, either using prints supplied by Fenton, or from prints bought at the auction by Frith. The latter is more likely for, as we have already seen, Fenton had other arrangements for distribution of his material during his working career as a photographer. The third possibility is that they were produced

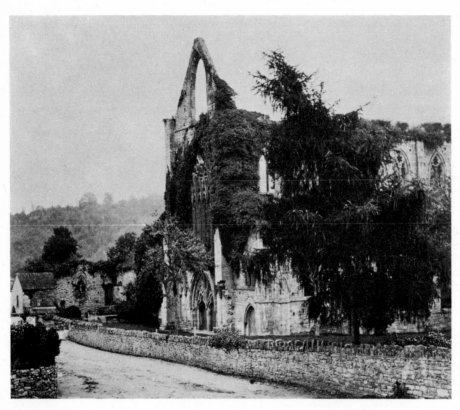

Tintern Abbey—from the volume entitled *The Works of Roger Fenton–Cathedrals* published by Francis Frith.

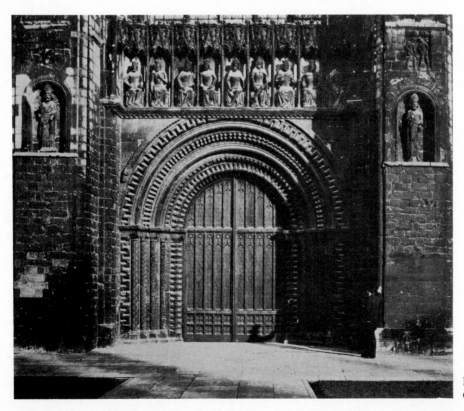

Lincoln Cathedral, the West Porch, also from *Cathedrals*.

View on the Llugwy, North Wales, from another Frith volume – this time *Landscapes*.

after Fenton's death, the prints being made by Frith's staff from Fenton's plates. Whether Fenton or Frith made the prints will probably never be clear but the presentation of the pictures, and the choice of title, would seem to suggest that the volumes were produced as a visual memorial to the photographer after his death.*

It would be reasonable to assume a date of 1870 for the publication of the Frith folio volumes. Unfortunately the records of Francis Frith and Co; do not go back far enough to tell us how many other volumes in the series were published or how many of Fenton's pictures found their way into Frith's files. The earliest Frith catalogue still in existence dates from 1892 and, surprisingly, there is no record of Fenton's material in that catalogue. Although many titles in the lists correspond with those produced by Fenton, close examination of the relevant prints has proved that most of the titles in Frith's collections as detailed in the catalogue are the products of the 1880s. However, in the next catalogue, drawn up in 1894, two prints, with serial numbers 34.339a and 34.341a appear, obviously late additions to the handwritten catalogue. These, two views of the Ribble and Hodder rivers in Lancashire, are from Fenton's Stonyhurst series of photographs dating from 1858.

Thus, strangely, thirty years after the auction sale, and over twenty years after the publication of the folio sets of Fenton's work, his photographs reappear in Frith's factory. Much of Fenton's material would not have appealed to Frith. One of the print-seller's requirements from a

*Two volumes of *The Works of Roger Fenton* have survived – entitled *Cathedrals* and *Landscapes* and are part of the Permanent Collection of the Royal Photographic Society.

Bed of the Garrawat, Braemar – from the same
Frith volume.

photograph bought by his company was that it should not have any people
in it – rapidly changing fashions in dress even in the Victorian era soon
made photographs outdated. Surprisingly though, one of the two pictures
which was added to the 1894 catalogue has two figures in the middle
foreground, very obviously dressed in the clothes of the 1850s.

Frith died in 1898 and the company carried on without him. When he
died, his company had distribution points in almost every town and village
in the country and was marketing the work of many now famous names.
His business was almost entirely made up from sales of prints to be pasted
into picture albums, or mounted prints of well-known views and buildings.

Very shortly after Frith's death, the decision was taken to launch the
company into the postcard market. Postcards had been fashionable for
some years before Frith's death but, surprisingly, the use of photographs
as illustrations was definitely not as popular as artwork. Raphael Tuck had
used photographs from time to time, but on nothing approaching the scale
on which Frith intended to enter the market.

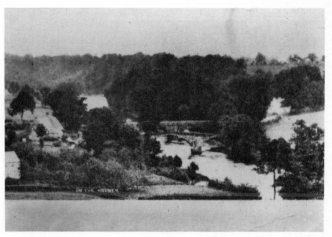

Double Bridges on the Hodder–taken by Fenton in 1858 and published in the *Landscapes* volume by Frith after Fenton retired from photography.

The same photograph–or at least a section of it used in one of Frith's earliest postcards, now retitled simply *On the Hodder*.

One of their first postcards, produced either in 1902 or 1903 was a view entitled *On the Hodder* produced from Fenton's view of the *Double Bridges on the Hodder*, and entered in Frith's 1894 catalogue as no 34.339a. This photograph, as already mentioned, suffered from one of the disadvantages which, in Frith's estimation, made it unsuitable for publication–the two figures in the middle foreground. However, a characteristic of pre-1903 postcards helped make this composition suitable for use. Only a small section out of the middle of Fenton's large 17×13 print was used in the postcard as can be seen from the accompanying illustration. It was the practise of the day to write postcard greetings on the picture-side of the card–postal regulations at the time allowing only the address and stamp to be on the back of the card. It was therefore necessary to leave a band of plain card at the foot of the picture where the greetings could be written. The provision of this band ensured that the offending figures were not visible. Thus, forty-five years after it was taken, the Fenton view was given a new if somewhat humbler lease of life as a picture postcard.

These cards were printed by the collotype process which preceded all the current methods of photomechanical reproduction of photographs and they were printed in Saxony. Later the production of Francis Frith postcards was taken over by the Cotswold Collotype Company which was responsible in 1973 for the printing of the superb series of prints from the Royal Photographic Society Collection entitled 'Masterpiece'.

The collotype process was a logical sophistication of the principles used in the 1850s by Paul Pretsch for his patent photogalvanographic process. Its advantage, over other printing processes available today is its remarkable similarity to photography. The image has no half tone screen as with modern offset litho, letterpress or gravure printing and on this point at least, early postcards had a characteristic which has been lost in their modern counterparts.

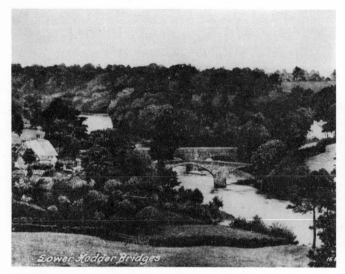

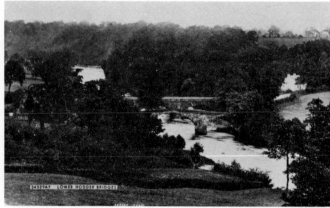

Several years later, and retitled once more, the picture appeared in a Frith booklet entitled *Ribblesdale*.

Until very recently, this postcard, still using Fenton's 1858 photograph was being produced by Photomatic Ltd.

The process involved the printing of the image from a photographic negative on to a light sensitive metal plate rather than a sheet of bromide paper. The negative was contact-printed on to the metal sheet coated with dichromated gelatine (Pretsch had used glue as his original base but specified gelatine in his later patents) and the exposed parts of the plate hardened by the action of light. The gelatine is then swollen by the application of water and glycerine – the amount of water absorbed being directly proportional to the degree to which the gelatine/dichromate has been hardened by light action. From then onwards, the principles are identical to those later used in litho-printing – the water repells the ink – more or less ink being repelled according to the water content. From the inked plate a limited number of prints could be made.

Friths' extended their range of publications in the early 1920s with the publication of an extensive series of picture books of towns and villages throughout the country. These were often produced by Frith and officially published by the leading stationer or bookseller in the town or area. Often though, in the absence of a bookseller willing to take on the actual publication and distribution, they would appear under Frith's own imprint. One such book was produced under the title *Ribblesdale* and, once more, print 34.339a was used, this time cropped slightly differently and given the new title and number 16B, *Lower Hodder Bridges*. This time the grass area immediately above the two figures was included to adapt the picture to the format required for the book but, of course, the figures were still carefully excluded.

Had the story of this one photograph stopped there it would be surprising enough, but it does not. In the 1950s Friths transferred the printing of their cards to Photomatic Limited of Hatfield. Photomatic were responsible for the printing of many of Friths' most recent cards including, once more 34.339a, now overprinted 34.339AF and given the same title as the picture in the 1920s book – *Lower Hodder Bridges*.

What is really unexplainable about the decision to continue using this picture–and it was used until 1970–is that the photograph on the recent postcard differs greatly from Fenton's original composition. Although there is no doubt that this is still the same picture, it has been heavily retouched. The fence in the middle of the hedge has been replaced by a continuation of the hedge; and the cottage and the edge of the farm building have been crudely retouched–no doubt because they are no longer standing. Noticing that the buildings had been removed merely suggested that the publishers had referred to modern maps before retouching the print and had noticed that the only building within view nowadays was the cottage on the opposite side of the bridge. Either the filling in of the fence is inspired guesswork, or someone was actually paid to visit the site and check the details. If the latter is the case, surely it would have been as cheap to rephotograph. (The bridge, now given a regrettable face-lift removing all the weeds and grass and replacing them with clean 1970s concrete is far less appealing but very different).

It is interesting to find, in a world where anything old is treasured merely on account of its age, that alongside the growing collections of Victorian photographs there was this one photograph, and perhaps many others, still finding a job to do in the commercial field for which it was originally taken.

From the auction sale of his material, there is ample proof that Fenton sold well over one thousand pictures. In the two years of research work for this book, a catalogue of existing examples of Fenton's work in the United Kingdom was compiled and, by completion of the work, totalled well over one thousand titles, usually with several copies of each. If we add to the thousand pictures sold in 1862, the three hundred and fifty titles from the Crimean expedition which were disposed of in 1856, we arrived at a total output by Fenton of at least fifteen hundred pictures. To that we can perhaps add at least another five hundred titles which we have failed to discover. It is probable that about fifty per cent of his total product has survived to this day and that the thousand titles listed in our catalogue represents the greater proportion of that percentage. It is hoped that the publication of this book will bring to light further examples of the works of Roger Fenton. Two copies of the catalogue of photographs by Fenton are available for use by students of photographic history and these are lodged at the Royal Photographic Society library and the National Photographic Record.

Postscript

While we have passed through the years in the company of Fenton's photographic undertakings, we have ignored the progress of the family.

While he was at college, and later involved in his legal and photographic careers, the family businesses and finances were not being advanced with the same degree of enthusiasm as were the affairs of Roger Fenton, photographer.

When Joseph Fenton died in 1840, as mentioned in the opening pages of this work, he left a vast fortune to John and James, Roger's father and uncle, neither of whom had any great interest in the banks, estates or Hooley Bridge Mills. The estates and the businesses had been shared between Roger's brother Joseph, and his cousin Joseph and, for a while, under their management, the businesses prospered. The banks had been given to Roger's brother William and the same cousin Joseph and they too thrived under their new ownership.

Although William and Joseph were actually in control of the Bank, the title still remained 'James and John Fenton & Sons, Bankers' and from 1845 onwards, for a substantial period, the bank's fortunes were on the incline—and in 1858 the company extended its services by acquiring further premises in Yorkshire Street in Rochdale.

The rates lists for that year show that the properties owned by the family had been extended too—with the purchase of several other estates. To the lists of Dutton, Bayley and Ribchester, with the mills in Rochdale and Hurst Green, had been added Grindlestone, Clegg Hall, Clough Bank, Wild House, Birchinley Hall and extended lands for the three original manors.

Over the following twenty years, however, the ascent of the family fortunes was cancelled by a much more rapid descent, arising out of a feud between the two cousins, Joseph and Joseph. Originally the pioneering Hooley Bridge Mills had been powered by the waters of the river over which it had been built and lit by the innovation of gas.

Roger's brother Joseph, who appears to have been in control of the Mill made the decision to abandon the convenient and free water-power and substitute steam engines to power the mill's machinery. Cousin Joseph objected and, as a result, a bitter feud erupted. A family war, of classic dimensions seems to have resulted with all the local members of the family taking sides. No decision could be reached and the matter was taken to court.

Both Josephs had had the mills valued, with a view to buying each other out but, with an impending court case, all work had to cease and the machines ground to a halt—putting three hundred people out of work and drastically cutting the real value of the company. With no income and huge legal expenses, the fabulous fortunes of the Fenton family soon dwindled.

In 1878 fate dealt another severe blow and the Bank failed. The fortunes were now at such a sad level, that Crimble Hall and the other properties had to be sold in order to meet the debts which the various disputes and failures had incurred. Only with the sale of the family home, Crimble, could the debts be met.

It had been hoped that, with the sale of Crimble, a full 20 shillings in the pound could be payed to the creditors. However, the wrangling did not really cease until 1892, by which time everything had been sold. The mills had realised £3050 in 1879 and the houses had been sold shortly after. On 2 December 1892, the final dividend was paid to the now ageing creditors making a total dividend of just over fifteen shillings in the pound.

The unfortunate feature of this collapse was the effect it had on the district as a whole. Fentons' Banks had been the commercial centre of Rochdale and the mills had been one of the largest employers. For almost two generations the whole town had basked in the reflected glory and comfort of the Fenton successes. When the collapse came, they also felt the cold chill of failure and hardship.

Plates

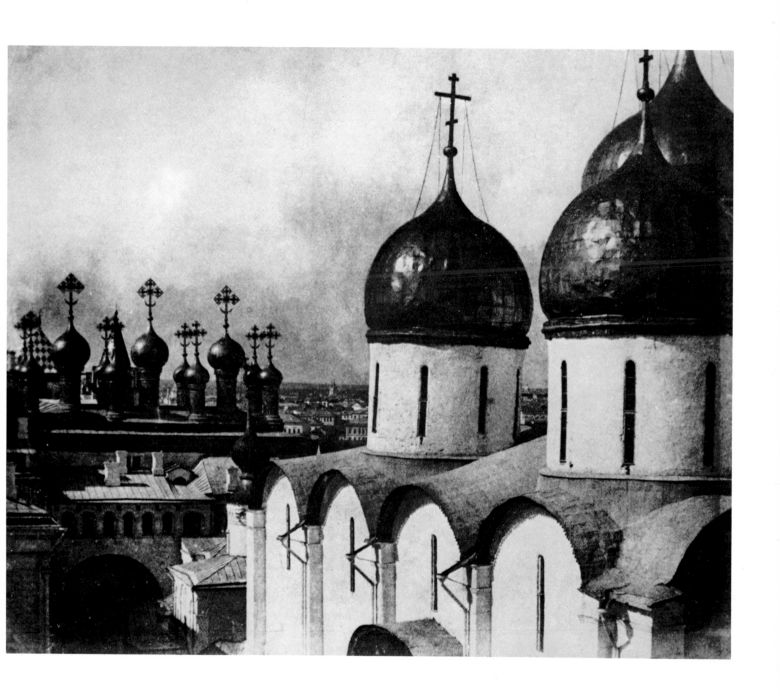

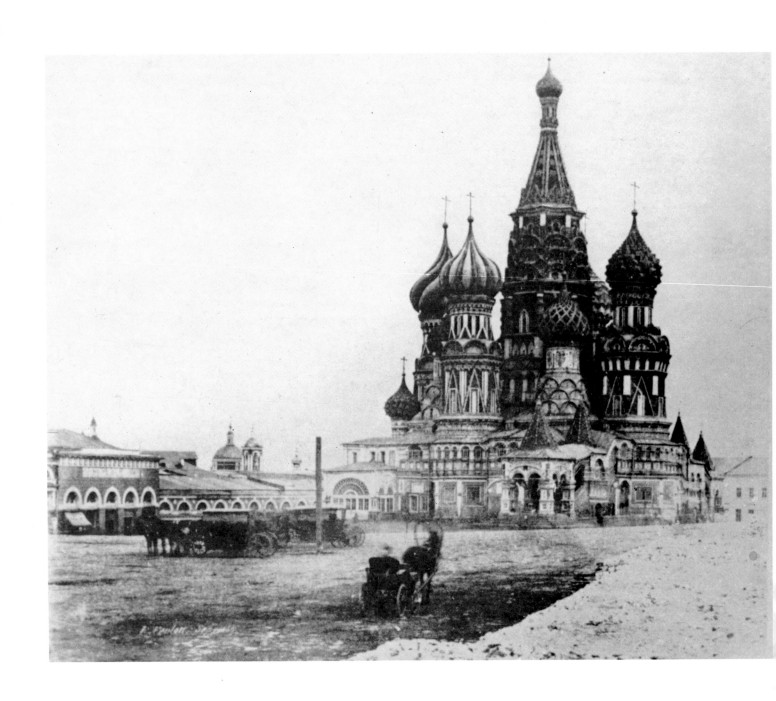

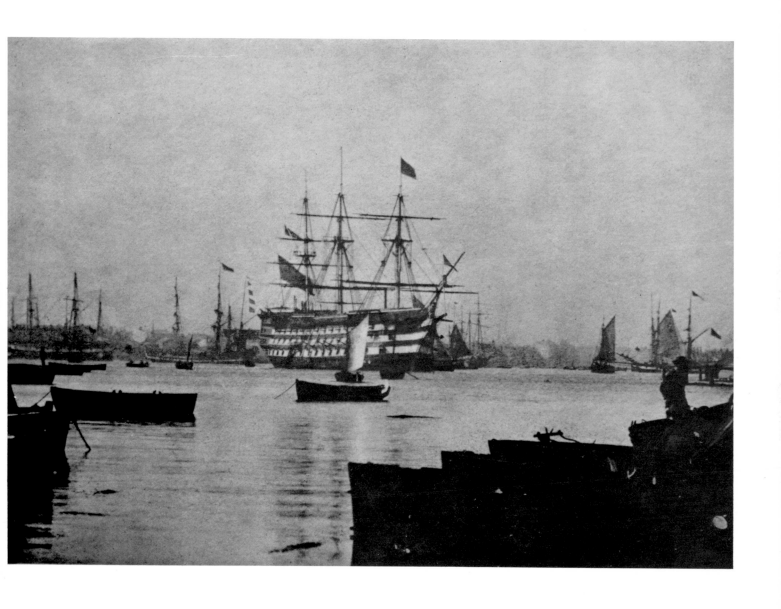

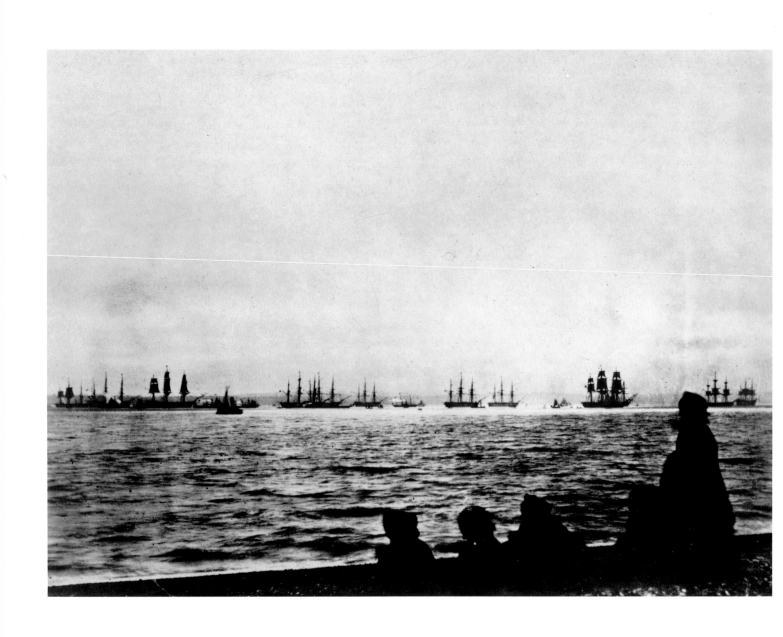

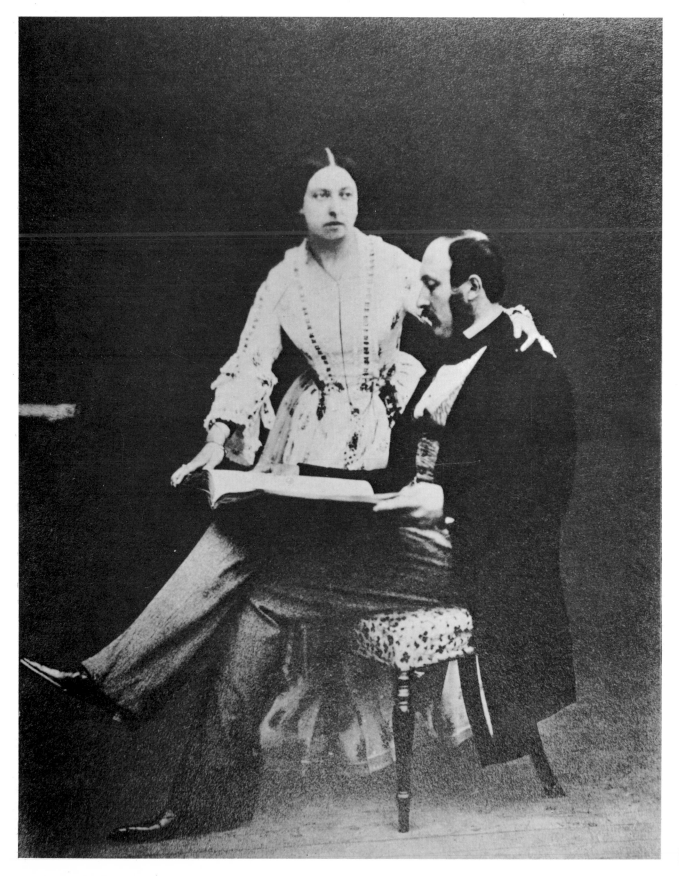

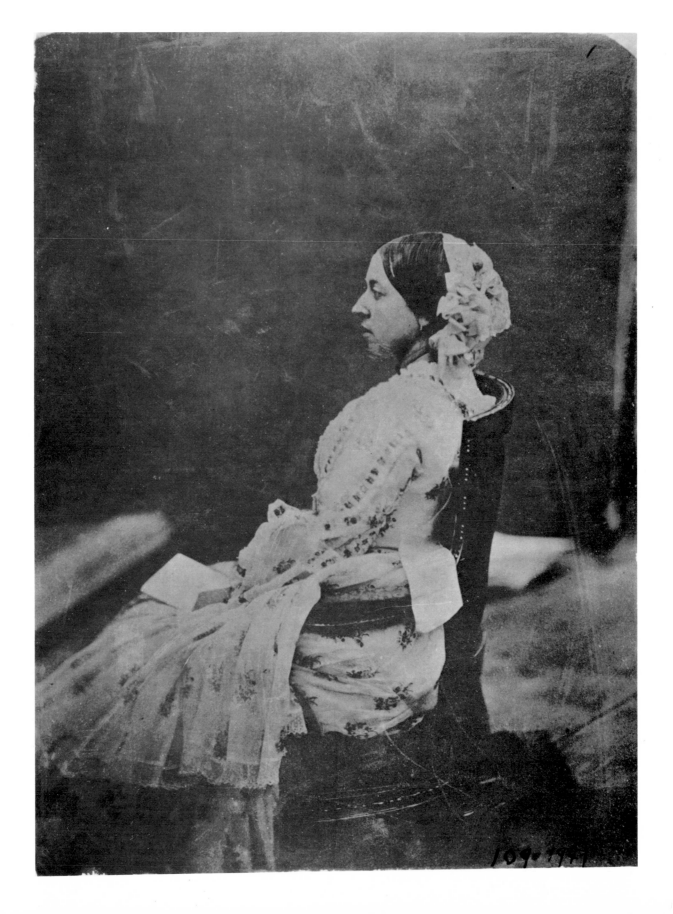

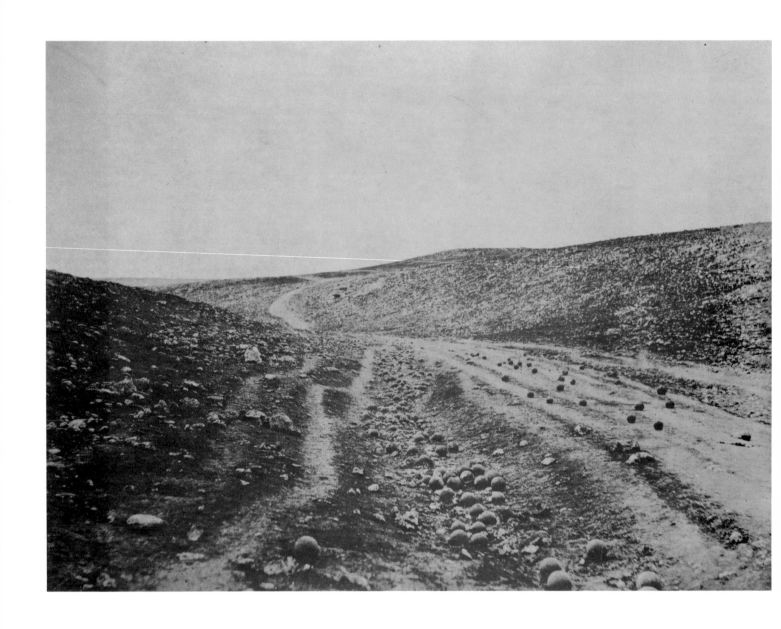

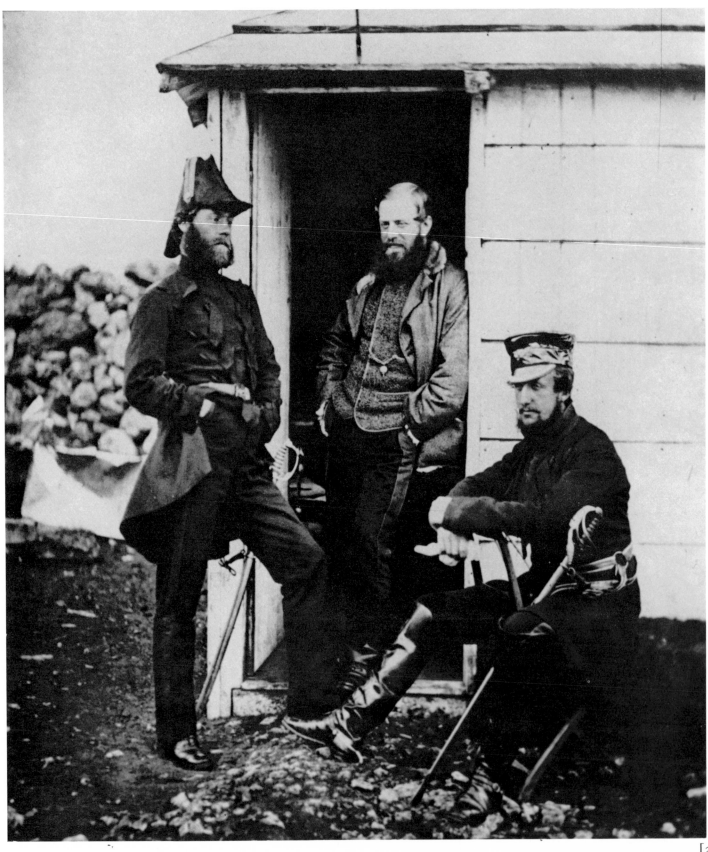

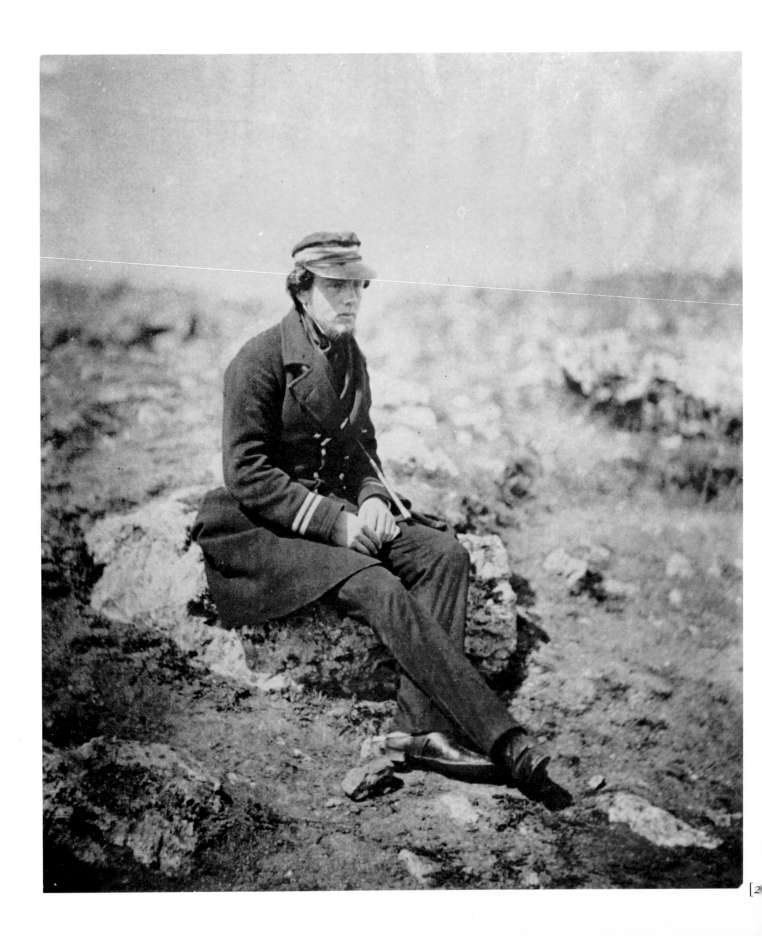

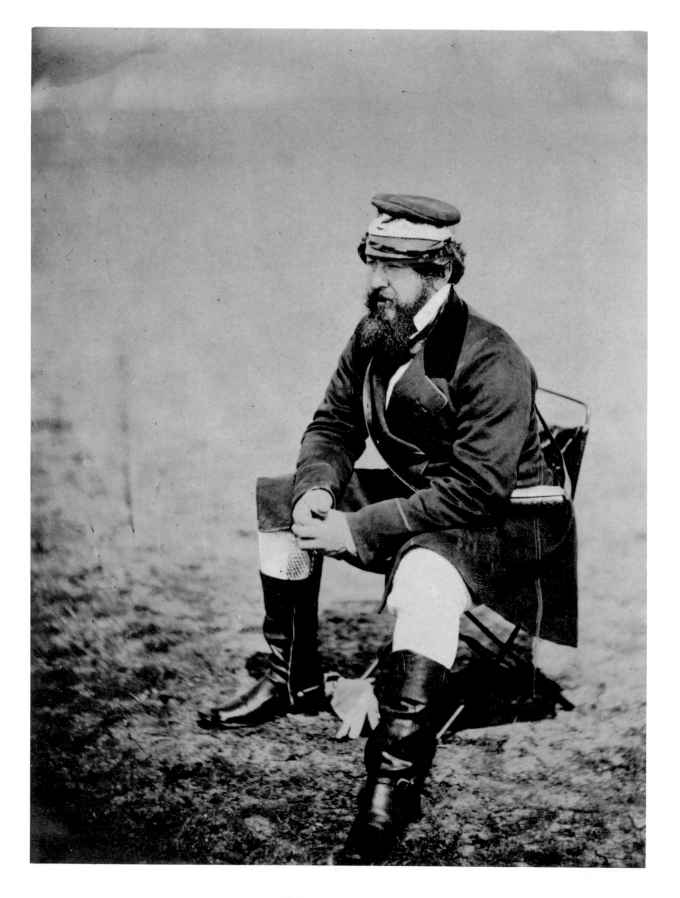

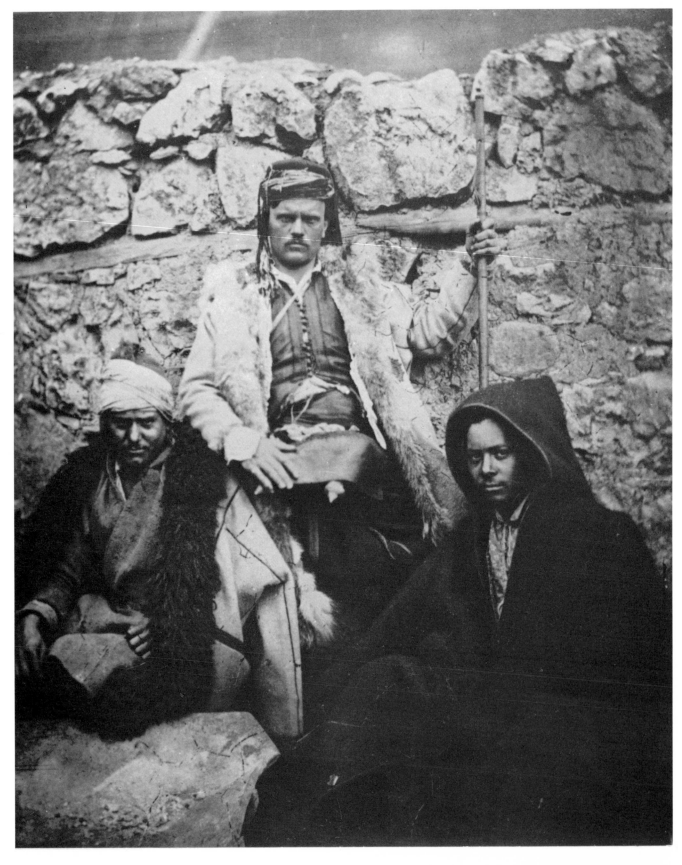

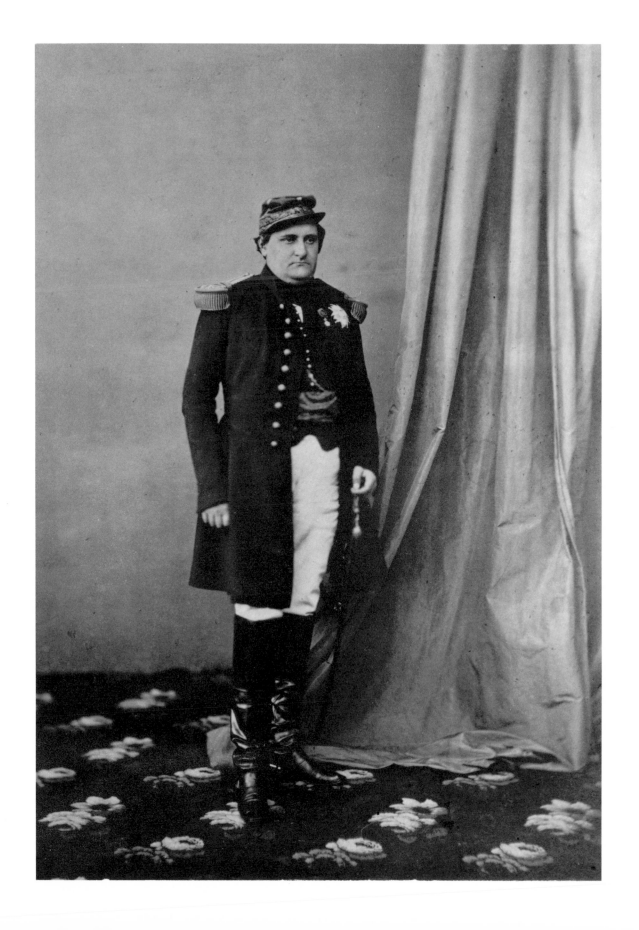

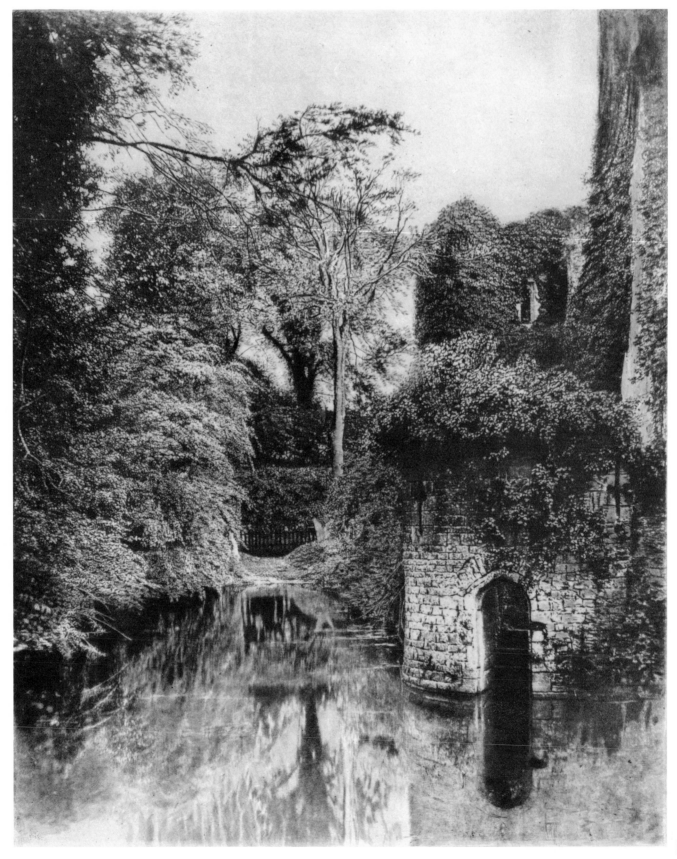

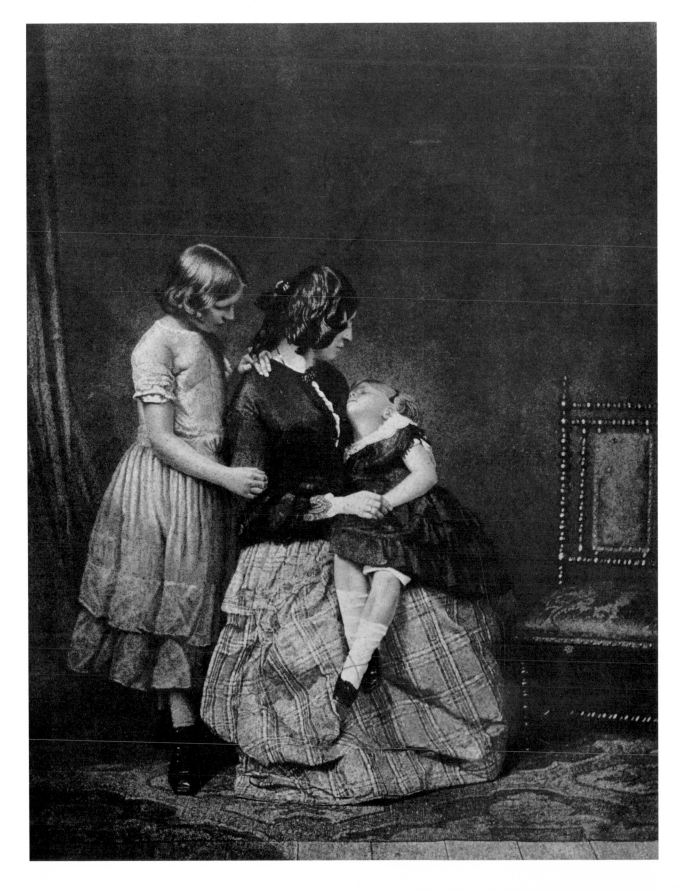

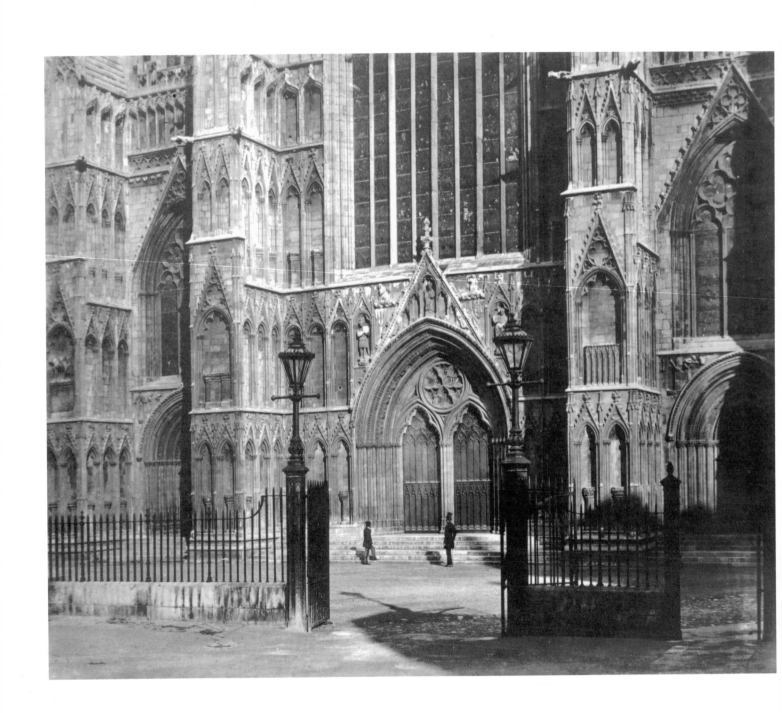

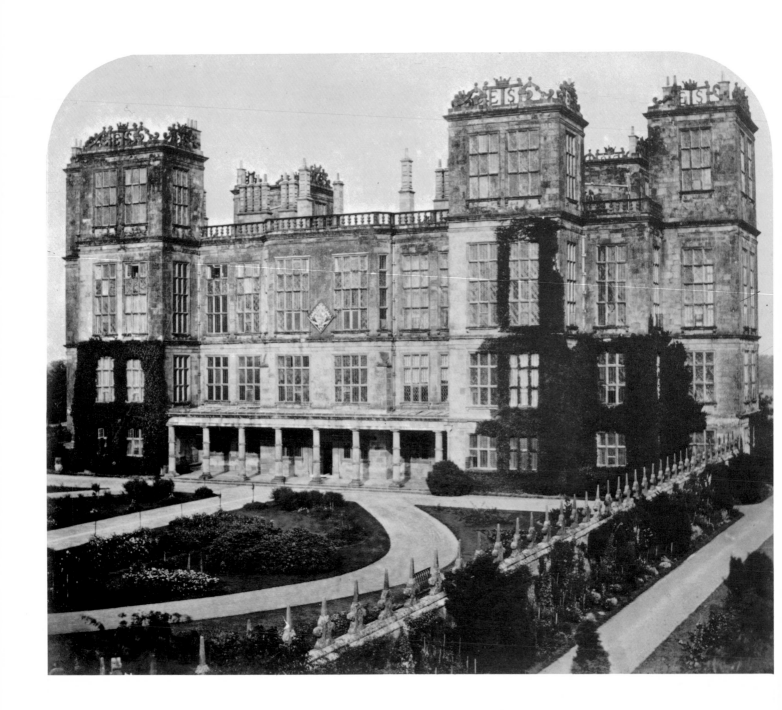

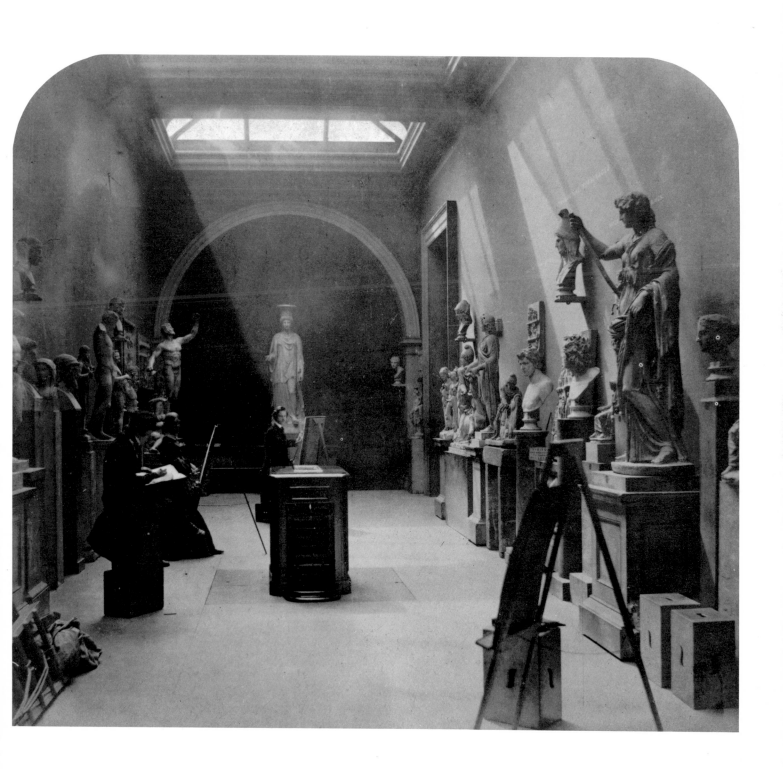

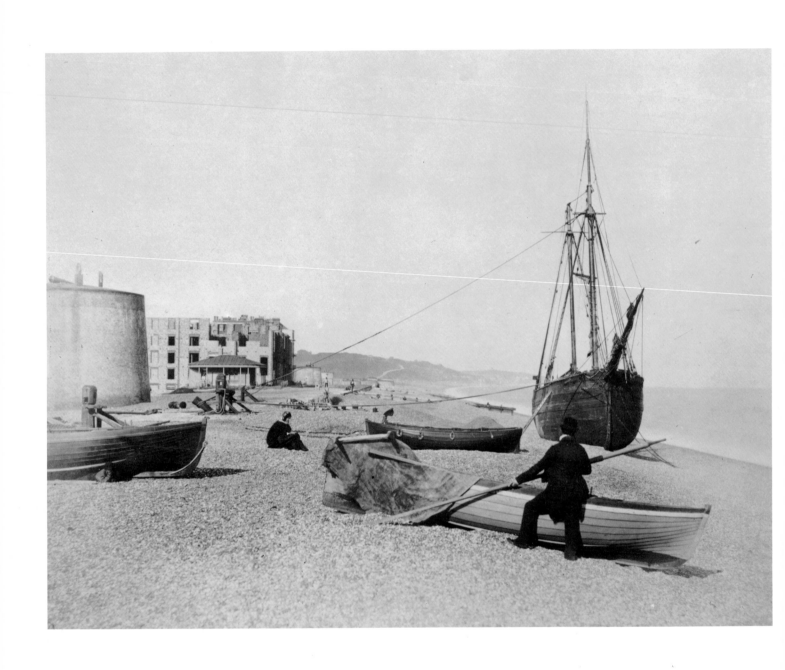

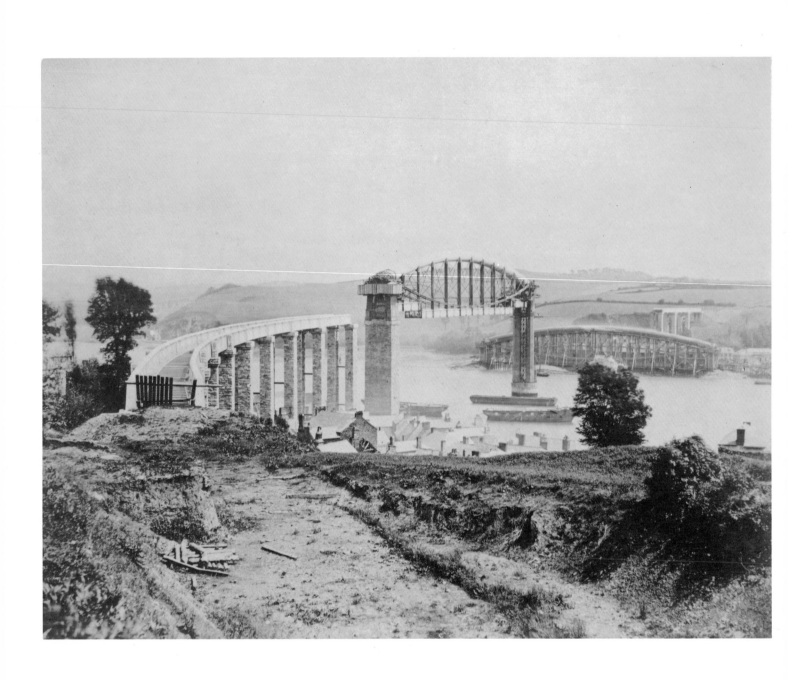

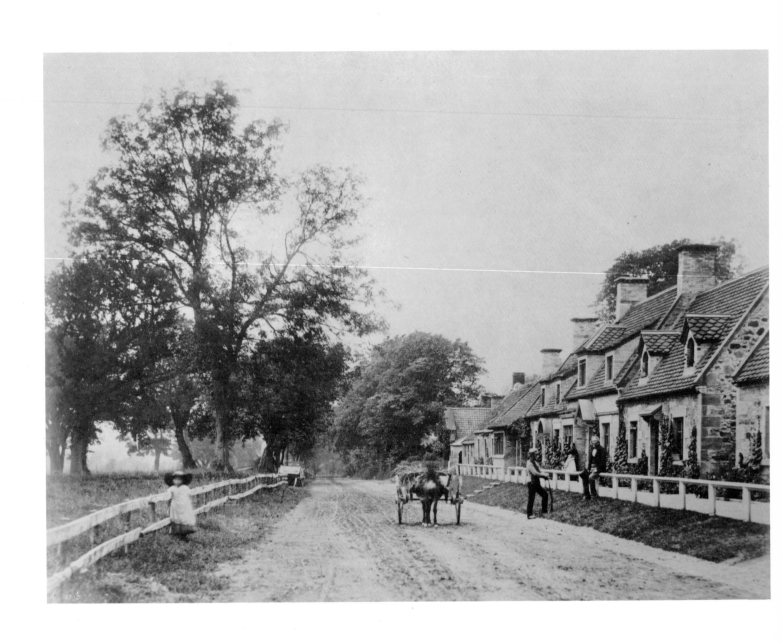

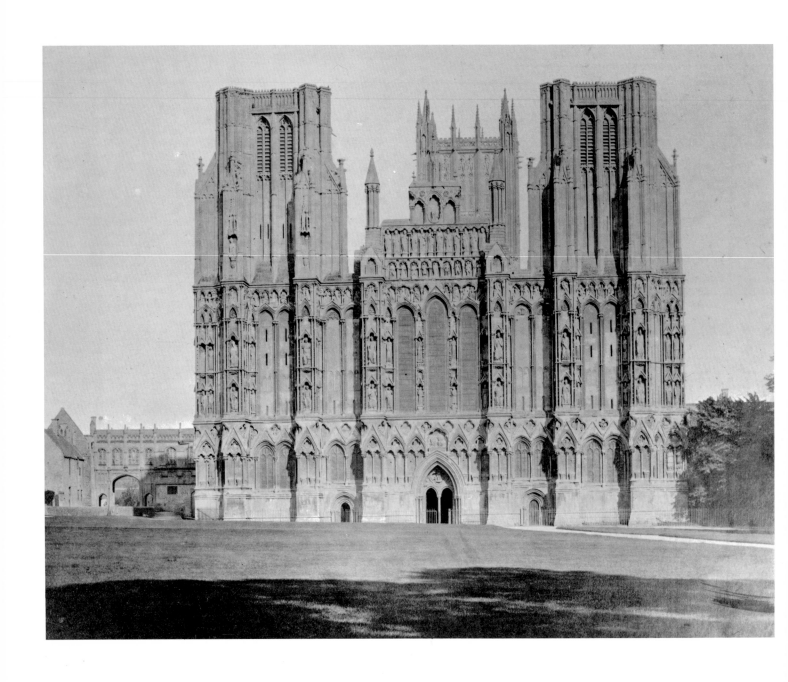

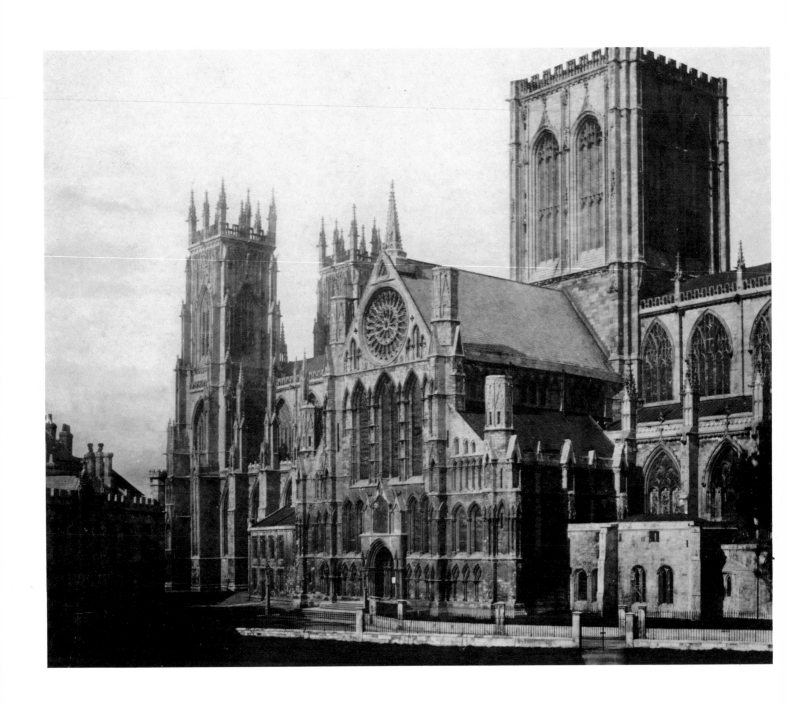

[59]

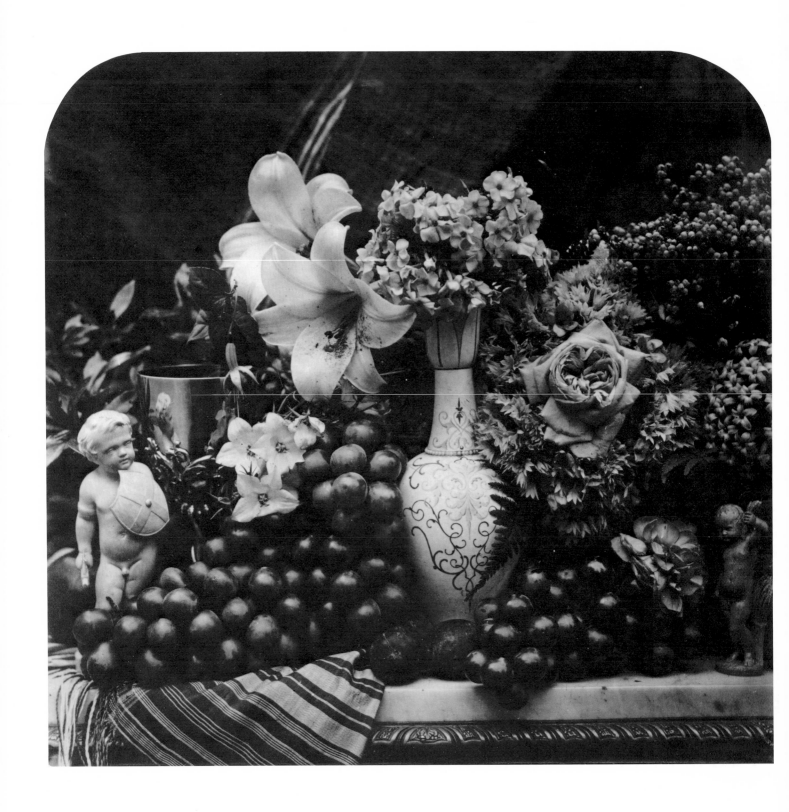

Notes to the Plates

Plate 1: *Domes of the Churches in the Kremlin.* Perhaps one of the most immediately recognisable of Fenton's Russian pictures, this view, taken in September 1852 has several alternative titles including *Domes of the Cathedral of the Resurrection.* Like all the Russian views, this was taken on waxed paper with the negative being printed on the original salted paper as produced by Fox Talbot.
Scottish United Services Museum.

Plate 2: *The Alexander Column and Winter Palace, St Petersburg.* If the serial numbers on these prints are to be believed, then Fenton took almost three hundred pictures in Russia. This beautiful study is numbered 251.
Scottish United Services Museum.

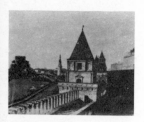

Plate 3: *External Walls of the Kremlin.* This rather powerful study shows one of the Kremlin buildings cacooned in scaffolding – undergoing a renovation perhaps. Taken in September 1852.
Scottish United Services Museum.

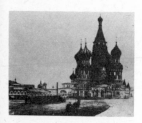

Plate 4: *The Church of St Vasili, Moscow, September 1852.* One of the very few images in this series which includes figures. Despite the lateness of the season, the light must have been sufficiently strong to enable Fenton to keep his exposures relatively short – the horse's head does not show too much movement.
Scottish United Services Museum.

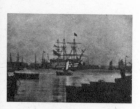

Plate 5: *The Victory in Harbour.* One of a series of photographs of the British Fleet taken in 1854 for Queen Victoria, this was perhaps the most impressive of Fenton's naval studies. The print, in the Royal Library at Windsor is not an original, but a carbon print produced by Mullins of Ryde in the Isle of Wight in 1893.
Reproduced by Gracious Permission of Her Majesty the Queen.

Plate 6: *The Queen and the Prince.* Fenton photographed the Royal Family extensively during the early part of his photographic career. This study, taken on 11 May 1854 is also reproduced from a carbon print made in 1893.
Reproduced by Gracious Permission of Her Majesty the Queen.

Plate 7: *The Princess Royal and Prince Arthur.* Taken on 10 February 1854, this tableau represents 'Summer' from the series entitled *The Seasons.* The long exposure must have presented quite a problem with such young children. Prince Arthur did not display the patience of his sister who remained quite still during the exposure.
Reproduced by Gracious Permission of Her Majesty the Queen.

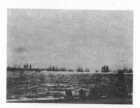

Plate 8: *The Fleet at Anchor, 1854 – the Fairy Steaming through the Fleet.* This is but one of a series taken at the Spithead in 1854 where the entire fleet of tall ships was gathered. Later pictures in the series show the empty sea after the fleet's departure.
Reproduced by Gracious Permission of Her Majesty the Queen.

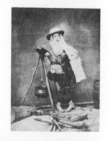

Plate 9: *The Prince of Wales as 'Winter' 10 February 1854.* In this picture from the series *The Seasons*, the Prince of Wales steadies himself by leaning on the supports for the cooking pot. This series took several days to photograph and many of the pictures produced were never published. Queen Victoria felt that some of them were not sufficiently dignified.
Reproduced by Gracious Permission of Her Majesty the Queen.

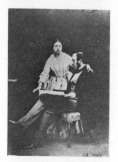

Plate 10: *'The Seasons' 10 February 1854.* Princess Alice as 'Spring', The Princess Royal and Prince Arthur as 'Summer', Prince Alfred as 'Autumn' and The Prince of Wales and Princess Louise portraying different interpretations of 'Winter', were each photographed separately and then together to provide us with this delightful 'tableau'.
Reproduced by Gracious Permission of Her Majesty the Queen.

Plate 11: *Queen Victoria and Prince Albert.* This less formal portrait of the Queen and her Consort is a perfect contrast to the portrait illustrated in the early pages of this portfolio. If the faces were not recognisable, this might be any couple photographed in their home.
Victoria and Albert Museum.

Plate 12: *Queen Victoria.* This seated portrait of Queen Victoria rounds off the selection of Royal Portraits produced in 1854.
Victoria and Albert Museum.

Plate 13: *Man and Male Gorilla*. In the years of work for the British Museum, Fenton must have been asked to produce some pretty bizarre pictures. From the academic world came requests for all types of material. It must have been interesting to photograph Assyrian Tablets before lunch and skeletons afterwards.
Victoria and Albert Museum.

Plate 14: *Gold Dish by Benevenuto Cellini*. No small size reproduction of this impressive print can do it real justice. The quality and definition of the original print must make it one of Fenton's finest productions, technically, during his British Museum days.
Royal Photographic Society.

Plate 15: *Aelius Caesar, Knight Collection, British Museum*. As one might expect with photographs which are intended primarily as archaeological records, these pictures have a substantial amount of additional information printed on the mounts. This bust, we are told, is 2ft 9¾ins high. A large collection of Fenton's output for the British Museum has survived, mainly in the Royal Photographic Society Collection. Surprisingly the British Museum itself does not have a single print from the many thousands supplied to them by Fenton between 1853 and 1859.
Royal Photographic Society.

Plate 16: *The Valley of the Shadow of Death*. Perhaps the most famous of all Roger Fenton's photographs, this evokes strong reactions from all who see it. Its quality is its suggestion of horror. The hundreds of cannon balls littering the once peaceful valley echo the noise and destruction of the battle which had so recently ended. This was as far as Fenton could go without actually photographing the bodies – and that he was forbidden to do. The actual photography of death was considered to be in bad taste and, bearing in mind that the expedition was a commercial venture, had therefore to be avoided if the prints were to achieve the public acceptance they needed.
Science Museum.

Plate 17: *The Harbour at Balaclava*. Almost as soon as Fenton's equipment was unloaded on to the quayside, he started taking pictures. These early photographs convey to us some of the bustle and industry which so impressed him on his arrival. The harbour was crammed with ships and the jettys were almost obliterated by the mass of men, machines and livestock which had been unloaded.
Science Museum.

Plate 18: *A Quiet Day on the Mortar Battery*. Due to long exposures, actual photographs of military action would have been out of the question. The easily posed pictures were often the only records of the battlefields. Thus much of the series consists of either portraits or carefully positioned groups of soldiers in anything but war-like situations. Later in the War, James Robertson did manage to capture a little of the action but this was limited to puffs of white smoke marking the positions of cannon.
Science Museum.

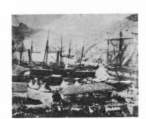

Plate 19: *The Ordnance Wharf, Balaclava*. This picture appears in the assorted volumes of Crimean pictures under three titles, the other two being *The Harbour, Balaclava* and *The Great Ships*. Like Plate 17 it was taken on Fenton's first working day in the port and gives us some idea of the strange array of craft, both steam and sail, which were used to ferry men and equipment to the 'Seat of the War'.
Science Museum.

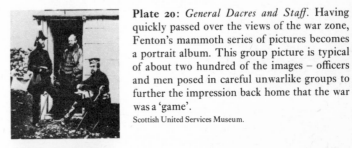

Plate 20: *General Dacres and Staff*. Having quickly passed over the views of the war zone, Fenton's mammoth series of pictures becomes a portrait album. This group picture is typical of about two hundred of the images – officers and men posed in careful unwarlike groups to further the impression back home that the war was a 'game'.
Scottish United Services Museum.

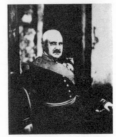

Plate 21: *Marechal Pelissier*. The three 'directors' of the Crimean War, Pelissier, Omar Pascha and Lord Raglan were each photographed individually by Fenton and then as a group in the picture which impressed Queen Victoria so much.
Scottish United Services Museum.

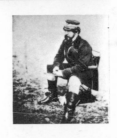

Plate 22: *Commander Maxse* from the albums of Crimean portraits. Notice how the positions taken up by the subjects of these photographs are as relaxed as possible. The exposure times were often as short as one second but still the photographer had to ensure that his subjects were comfortable enough to remain absolutely still.
Scottish United Services Museum.

Plate 23: *Sir William Russell, 'The Times' Correspondent*. It was the original reports sent back by Russell which first interested Thomas Agnew in the idea of sending Fenton out to record views of the war. The Crimea was covered from many angles and in many styles – often giving entirely different impressions of the conditions and the conflicts. The people at

home first reading Russell's reports, then viewing Fenton's pictures and finally William Simpson's sketches could be forgiven for thinking there were three different wars being waged!
Victoria and Albert Museum.

Plate 24: *Croats.* Many races and colours were brought together in the war effort. These three Croat chiefs appealed to Fenton's photographic eye and at least two different group portraits of them were included in the series.
Scottish United Services Museum.

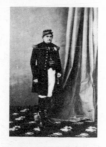

Plate 25: *His Imperial Highness Prince Napoleon* – Royalty at the seat of war.
Victoria and Albert Museum.

Plate 26: *Mr Angel, Postmaster.* Like the Croat chiefs, Mr Angel became a subject for Fenton's camera on more than one occasion. In his hands was the safe delivery of all mail to and from the substantial British presence in the battlefield.
Scottish United Services Museum.

Plate 27: *Raglan Castle, the Entrance.* This view of Raglan is one of a series taken at the same time as the stereoscopic view illustrated in the text. In fact close examination of the stereoscopic print will show the large format camera set up ready in front of the doorway.
Royal Photographic Society.

Plate 28: *Raglan Castle, the Watergate.* When Paul Pretsch published the first of his photo-galvanographic prints, he used photographs by Fenton, his chief photographer. This print appeared in October 1856.
British Museum.

Plate 29: *The Porch, Raglan Castle.* This second photo-galvanographic print, also in the first folio, was produced by the early version of the process. The need for retouching had not yet been removed giving the picture a quality which was neither photographic, nor entirely engraved but a rather unhappy marriage of the two.
Rochdale Library.

Plate 30: *Hush, Lightly Tread.* Fenton had frequent forays into the world of the 'tableau', none of them entirely successful. The results were uniquely Victorian and heavy with domestic drama!
Manchester City Libraries.

Plate 31: *The Keepers Rest, Ribbleside.* Fenton here used the grandeur of the steep banks of the Ribble in Lancashire to offset the tiny group of keepers with their dogs. The picture forms part of the large set of views of the Ribble and its tributary, the Hodder, taken in 1858.
Stonyhurst College.

Plate 32: *Pool in the Ribble.* Once again the relationship between man and his environment produces a strong composition.
Stonyhurst College.

Plate 33: *Morning, the Keeper's Round.* No reproduction can do justice to the quality of the original print. The carefully printed gold-toned picture is one of the highlights of the entire Lancashire series.
Stonyhurst College.

Plate 34: *A Vista, Furness Abbey.* Furness appears to have been another of Fenton's 'pet' subjects. He took at least thirteen photographs there of twelve different views. There is another picture of the same subject as this where the photographer has varied his exposure to produce a totally different result, – less dramatic, but nonetheless beautiful.
Royal Photographic Society.

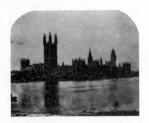

Plate 35: *Houses of Parliament Under Construction*. Photographs of famous landmarks under construction have a strange appeal and fascination for us today. They differ from many Victorian photographs because they can be dated specifically and recognised as period pieces. Many landscapes and architectural photographs differ from those of today only in the name of the photographer. But like Hill and Adamson's views of Edinburgh's Scott Monument under construction, views such as this are important primarily as historical documents.
Royal Photographic Society.

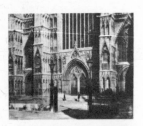

Plate 36: *York, the West Porch*. One of Fenton's magnificant views of York Minster, this picture ably exhibits Fenton's preference for filling the frame in his architectural photographs.
Royal Photographic Society.

Plate 37: *Fors Nevin on the Conway*. It was romantic and beautiful compositions like this which were seen by J. B. Davidson in 1858 and prompted him to retrace Fenton's steps and produce the text for *The Conway in the Stereoscope*.
Royal Photographic Society.

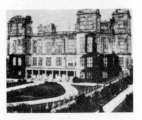

Plate 38: *Hardwick Hall*. Fenton has overcome the problems of obvious converging verticals in a photograph of such a tall building taken from ground level, by elevating his camera position either to a balcony or window in the building opposite.
Royal Photographic Society.

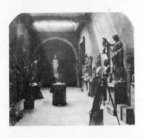

Plate 39: *British Museum c.1854*. This view was obviously photographed at the same time as the stereo pair known as *The Graeco-Roman Salon, British Museum* used in the *Stereoscopic Magazine* and illustrated in the text of this book. Fenton here demonstrates once more his superb control of lighting – the control we have seen in the photographs of Stonyhurst's Refectory.
Royal Photographic Society.

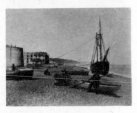

Plate 40: *On the Beach, Hythe, 1860*. I think that part of the appeal of this photograph is that it is unlike anything else that Fenton produced. The composition, however, shows the perfect balance which was Fenton's hallmark. We have alternative compositions for most of Fenton's studies involving people – with different groupings of the figures in each. It would be interest-

ing to know how many attempts he made to get this very precise composition right – or was this his first and only attempt?
Royal Photographic Society.

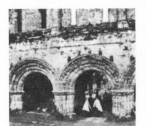

Plate 41: *Entrance to the Chapter House, Furness Abbey*. The solid masonry above the squat arches has been used here to give weight to the building and dwarf the group of figures. This, in architectural terms instead of landscape, is a very similar composition to *The Keepers Rest, Ribbleside*.
Royal Photographic Society.

Plate 42: *The Terrace and Park, Harewood House 1861*. Although severely criticised and badly received at their first public exhibition, these photographs taken at Harewood are now rightly accepted as being the zenith of Fenton's photographic career. The strong pattern of lines which caused their rejection in 1861 is just what appeals about them today.
Reproduced by Courtesy of the Earl of Harewood.

Plate 43: *Paradise, a view near Stonyhurst*. A small boy, borrowed from the college and framed by tall dark trees produces a strong composition in this view of the River Hodder in Lancashire.
Stonyhurst College.

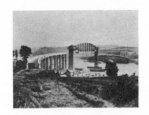

Plate 44: *Saltash Bridge between Devon and Cornwall*. The Saltash Bridge was opened in 1859 and therefore we can assume that this photograph was taken in 1858 or perhaps early 1859 – although the unlaid railway track would suggest the former date. The bridge was built by Isambard Kingdom Brunel and for over a century its single rail track was the only link across the River Tamar. Now a modern suspension bridge crosses nearby.
Royal Photographic Society.

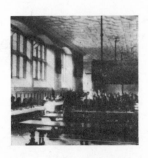

Plate 45: *The Refectory, Stonyhurst*. Fenton took two photographs of the old refectory at Stonyhurst College – one with the room empty except for a few servants. The first shot, with the near-empty room might have been a test shot for this view.
Stonyhurst Collection.

Plate 46: *Falls of Ogwen, North Wales*. The North Wales pictures were first exhibited at the end of 1858 or early 1859 and form one of Fenton's best series of landscapes.
Royal Photographic Society.

Plate 47: *Lincoln*. Photography as the recorder of change – it is sad that Lincoln no longer looks as appealing and tranquil as in this picture. Probably taken in 1857, this view contrasts vividly with the possible views of the city today.
Royal Photographic Society.

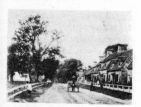

Plate 48: *Foulden near Berwick*. Compared with the attention he devoted to England and Wales, Scotland was not a land to which Fenton ventured often. This present subject, the village of Foulden, required him to travel only about one and a half miles over the border.
Royal Photographic Society.

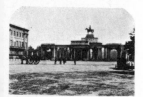

Plate 49: *Hyde Park Corner*. This picture is even more of a contrast with the present day than the view of Lincoln.
Royal Photographic Society.

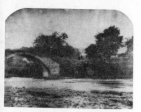

Plate 50: *Old Lower Bridge, Hodder*
Stonyhurst College.

Plate 51: *Helmsley Castle, the Fosse*. The original print from which this copy has been made can hardly have lost any of the quality of Fenton's printing despite the one hundred and fifteen years since it was made.
Royal Photographic Society.

Plate 52: *Grindlestone*. Another of the Fenton family's houses, this small farm on the rich agricultural lands between Ribchester and Hurst Green also caught the photographer's eye in 1858.
Stonyhurst College.

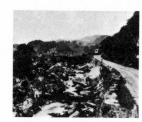

Plate 53: *Pont-y-Pant on the Lledr, North Wales*. The first large format view of Fenton's second 'Photographic Carriage'. This wagon, built by Homes of Derby, replaced the vehicle abandoned at the end of the Crimean photography before Fenton returned home. The van can also be seen at the end of a long lane in one of the stereoscopic views from North Wales.
Royal Photographic Society.

Plate 54: *The Bobbin Mills, Hurst Green*. The Fenton family owned these mills in Hurst Green village and used the bobbins they made in the Hooley Bridge Cotton Mills in Rochdale. Fenton's visit to this corner of Lancashire might have been part business, part pleasure.
Stonyhurst College.

Plate 55: *Changing Guard at Windsor Castle*. Fenton's friendship with the Royal Family led him to produce an extensive series of views of Windsor. These pictures along with the portraits became treasured possessions of the Queen and the Prince.
Reproduced by Gracious Permission of Her Majesty the Queen.

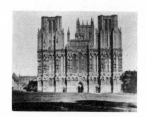

Plate 56: *Wells Cathedral, the West Front*. Considering the equipment at his disposal and the processes of the time, architectural views such as this taken in the 1850s are permanent memorials of the skill and patience of the photographers.
Victoria and Albert Museum.

Plate 57: *Christmas Day 1859*. Fenton returned to Stonyhurst a year after his original visit to present the results of his work to the school and to thank one of the priests, Father William Kay, for his help the previous year. A few of the photographs taken on that second visit survive – amongst them this ambitious picture of boys skating on the frozen pond. Lancashire in winter must have yielded only a fraction of the light available in the Crimea in the summer. The days of one second exposures were well past when this was taken and one can presume that the boys had to stand still for twenty seconds or longer. The length of exposure appears to have been too long for many who appear as faint ghosts on the print.
Stonyhurst College.

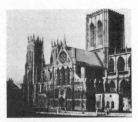

Plate 58: *York Minster from the South East.* Roger Fenton took a large number of views of York Minster, visiting the city several times during his photographic career. The church is an obvious choice as a photographic subject and Fenton's skilful treatment has produced a series of pictures of unrivalled beauty.
Royal Photographic Society.

Plate 59: *Wall of Rock, Cheddar.* A simple yet powerful composition, this picture owes its success to a perfect choice of viewpoint. If it lacks anything, it is perhaps a figure, or some other point of reference with which to compare the solid wall of rock.
Royal Photographic Society.

Plate 60: *A fresh on the Hodder.* A photographic necessity for Fenton and his contemporaries was a long exposure time. This necessity gives a unique quality to all photographs of running water produced at the time, giving the water a rich velvet appearance unique to the early days of photography's history.
Stonyhurst College.

Plate 61: *Hurst Green* also known as *Cottages in the Dene* this is one of a series of variations on the same view which Fenton took, varying the grouping of the people until he achieved his 'ideal' composition.
Stonyhurst College.

Plate 62: *Raid Deep with Pendle in the Background.* It would appear from studying Fenton's work, that perspective and its control and manipulation had a fascination for him. Wherever possible he uses the ready-made straight lines produced by man and nature to add a feeling of depth in his views. This is exhibited in the *Avenue in the Garden, Stonyhurst*, again in *The Terrace and Park*, Harewood and in this view.
Stonyhurst College.

Plate 63: *Stonyhurst College.* While in Lancashire, Fenton could hardly ignore the central architectural landmark of the area.
Stonyhurst College.

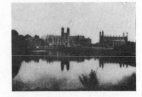

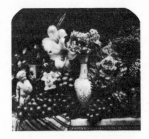

Plate 64: *Vase, Flowers and Fruit.* The plate section of this biography finishes, aptly, with one of Fenton's final photographic exercises – a still life. The original of this print must be one of the most beautiful of the thousand which have been studied in the compilation of this book. Fenton's 'swan song' leads the viewer only to regret that this is the last. The subject matter has a limited appeal but the technical excellence of the photograph could hardly be bettered today.
Royal Photographic Society.

Index